Coming to Terms

Subject
Search Strategies
in the School
Library Media
Center

Terms

Regin

D1457105

Neal-Schuman Publishers, Inc.

New York London

ACKNOWLEDGMENTS

The drawings that appear in transparencies 1.1, 2.1, 2.17, 3.1 and 3.3 are credited to Erik Blackburn Oliver.

Published by Neal-Schuman Publishers, Inc.
100 Varick Street
New York, NY 10013

Printed and bound in the United States of America

Library of Congress Cataloging-in-Publication Data

Moody, Regina B.
 Coming to terms : subject search strategies in the school library
media center / by Regina B. Moody.
 p. cm.
 Includes bibliographical references and index.
 ISBN 1-55570-225-2
 1. School libraries—United States. 2. Instructional materials
centers—United States. 3. Searching, Bibliographical.
4. Information retrieval. I. Title.
Z675.S3M54 1995
027.8'222'0973—dc20
 94-37893

Contents

Preface 3

Introduction 5

Chapter 1. Beginning the Search 9
Introduction 9
Lesson 1: Assessing Student Search Skills 11
Lesson 2: Search Word Strategies 13
Lesson 3: Plan Before You Leap 17

Chapter 2. Searching by Subject in the Library Catalog 24
Introduction 24
Lesson 1: Finding the Common Denominator 26
Lesson 2: Understanding Subject Cataloging 28
Lesson 3: Getting Unstuck—Adding Search Words 32
Lesson 4: Pass the Pilgrims, Please 35
Lesson 5: The Relationship of Terms—Pilgrim, Place, Thing 36
Lesson 6: Picture This Pilgrim Search 38
Lesson 7: Coming to Terms with the Library Catalog—Pilgrims Found 40

Chapter 3. Finding an Information Trail Through Indexes 74
Introduction 74
Lesson 1: Identifying Cross-References in Encyclopedias 76
Lesson 2: From Index to Article and Back—Finding More 78
Lesson 3: Almanacs—The Super Index 80
Lesson 4: Searching the Yellow Pages 82
Lesson 5: Go to It! Looking Up Places You Know in the Yellow Pages 84
Lesson 6: Getting into Magazines 86
Lesson 7: Poetry from Several Directions 89

Chapter 4. Introducing Electronic Storage of Information 102
 Introduction 102
 Lesson 1: Databases—Computers House Information 103
 Lesson 2: Databases—Computers Hand It Over 105
 Lesson 3: CD-ROM/One-Stop Shopping? 108

Chapter 5. Accelerated Access Through Automation 113
 Introduction 113
 Lesson 1: Online Search by Title and Author 115
 Lesson 2: Coming to Terms with Online Subject Searching 119
 Lesson 3: When the Subject Is Biography 121
 Lesson 4: Keyword Search—Widening the Possibilities 124

Chapter 6. Modifying the Subject Authority: Cataloging for Kids 155

Chapter 7. Designing Topical Search Assignments: Collaborative Planning 159

Appendix A. Topics for Cross-References 163

Appendix B. Suggested Online Services and Database Software 165

Appendix C. Templates for Transparencies 167

Bibliography 174

Index 177

Preface

Information literacy is a principle that guides reform of both school curricula and instructional practices. An increased understanding of student behavior and of how young people learn—gained through research in education, psychology, and library and information science—underscores the need for active involvement by students as they develop skills of inquiry and as they learn how new information links with their existing knowledge.

Young people are actually quite sophisticated in obtaining answers about the world. This is not a comment about being "street smart," but about natural learning by children as they interact with their environment. By the time they reach the late elementary school years, children have had much practice in recognizing personal information needs. Early on, their innate curiosity progresses through the "what/where" stages (pointing and naming in infancy), to the "why/how" stages (the preoccupation of toddlers). The ability to locate and evaluate information increases as they grow. They utilize skills of observation and trial-and-error learning; they analyze what others say and how they say it. Practical application of new learning is a natural occurrence. Intermediate-age children have become quite effective users of information in their personal worlds.

Yet, as students progress through school, where emphasis is placed on mastering specific reading skills, their focus is narrowed from real-life experiences to academic exercises where they extract fragments of information from print to satisfy the demands of test taking. Inevitably, the reliance on textbooks has limited opportunities for the refinement of information search skills, and it results in nonthinking behavior and frustration when students attempt to use library resources for assignments or personal interests. What was once the innately rewarding experience of gathering information to answer questions or solve problems becomes, for many, confusing and something to be avoided whenever possible.

The materials in this publication represent a departure from traditional library skills instruction manuals. I believe there is a better way. Teaching "the process" begins with an examination of each prerequisite skill for an information problem-solving situation so that appropriate lessons can be designed. The teacher must then articulate and demonstrate the thinking involved in solving the problem. I have spent many years developing a program of library instruction in which classroom teacher and library media specialist share responsibilities for planning and implementation. Using this approach, lessons evolve out of instructional context, and the school library media collection serves as an information-rich laboratory for discovery.

In general, intermediate-age students hold certain assumptions about libraries. They know that information has been collected, organized, and "packaged" in many formats, including books, magazines, audiovisuals, and computer programs. They also know that they will have to read and evaluate whatever

information they find. What they often do not understand is how to get started. They do not know how to begin a search when faced with so many options, or how to locate likely information sources. *Coming to Terms: Subject Search Strategies in the School Library Media Center* is a systematic effort to encourage young people to reflect upon the entire process of information problem-solving; it focuses, however, on essential first steps—locational skills.

Introduction

Gaining access to information is a dynamic process that involves both intellectual and physical manipulation of resources. A variety of strategies are used in the initial stages of any investigation. The term "search word strategies" in this publication refers to methods for determining and selecting likely indexing terms once a particular information source or format has been chosen. These strategies form the student's mental plan for gaining access to the stored information. In the professional literature, one finds variation in the use of the term "strategies." I believe that "search word strategies" is a designation easily understood by intermediate-age students, and that these words closely approximate Bates's use of "term tactics" (Bates 1979).

Students' success in finding needed information in either print or computer formats relates directly to their skill in using indexes—indexes that then lead to articles, abstracts, chapters, etc. What they do with a source (i.e., how they analyze, evaluate, and communicate the information) is the final point, of course. But, to skip the first steps, or to underestimate the complexity of the process, can be detrimental to students.

We must help them "come to terms" with how they gain entry into resources by providing opportunities for subject searching in all curriculum content areas and for using the widest possible range of materials. By articulating the process, we increase comprehension and chances for success (Bates 1979).

DEVELOPMENTAL READINESS OF STUDENTS

The lessons included in this publication are appropriate for students as they move through the upper-elementary and intermediate grades. By this age, the capacity to monitor one's own thinking and comprehension is beginning to develop. Just as prior exposure to library organization and knowledge of basic information sources are prerequisite to the lessons presented, so, too, students must be developmentally ready for the cognitive demands inherent in the activities (Kulleseid 1986). These lessons were not designed for academically talented or gifted students. They reflect the needs and interests of most children in these grades.

I believe that the upper-elementary age is an optimal period for introducing the concepts of information search when the process includes adult assistance and prompting. The reader is directed to Bertland's article, which links instructional practices to metacognitive skills instruction (Bertland 1986).

LESSON DESIGN

In designing each section, I gave consideration to the knowledge to be acquired, to prerequisite skills, and to anticipated difficulties that students might face. Lessons are structured so that concepts progress from simple to complex. The first examples given demonstrate common occurrences; exceptions and variations follow. Questions in the lessons were worded to stimulate active student participation and to encourage critical thinking and discovery. Group brainstorming is suggested in some lessons to help clarify factual and conceptual relationships. Throughout the activities, learners are asked to articulate their thought processes in arriving at an answer, rather than simply responding with a statement of "fact." A concise description of these and other key elements in teaching strategies that foster student thinking and active involvement can be found in the article by Hughes listed in the Bibliography (Hughes 1986).

Good teaching leads to the gaining of insights by learners into their own behavior; that is, students come away with ways to facilitate their own comprehension and evaluation of the process. "Thinking aloud" is an accepted strategy to facilitate reading comprehension. Various thinking-aloud techniques that can be verbalized by the instructor include making predictions, articulating confusing points, and deciding what to do next if one's first plan of action did not work (Davey 1983). These are particularly helpful in decisions regarding searchable terms in indexes.

I believe that the lessons will have the most lasting impact if students are handling the resources in their own school library media centers. Therefore, the transparencies and examples included in this publication should first be checked against the specific local collection and modified accordingly. Whenever materials are pulled ahead for use in a presentation, their usual shelf location should be made clear to the students. The lessons should thus utilize real materials in a familiar setting while pointing out generalities that may allow for transfer of the student's new knowledge to other information problem-solving situations.

EXPLANATION OF LESSON FORMAT

Each lesson begins with a stated objective. The material is then presented in one of two formats:

1. *Descriptive Lessons.* Learning activities are suggested, and a basic outline is included. The lessons are intended to be designed by the instructor for a particular group of students and for available class time.

2. *Narrative Lessons.* Model lessons have been carefully structured and scripted for teaching effectiveness. They should be viewed as models, and adjustments should be made as needed.

Black-line masters for creating transparencies or photocopies of the illustrative materials follow the lessons at the end of the chapter. Templates for making original illustrations from the reader's library catalog can be found in Appendix C.

I have adopted a lesson format that includes elements of guided practice and of checking for student understanding so that comprehension can be observed. While students may show varying levels of competence, most can be expected to achieve all the objectives. If necessary, however, the instructor must slow the pace, work through more examples with the class, or redesign the activities. At the end of every lesson, each student, whether involved in an individual task or in a cooperative learning situation, should feel successful. The teacher and the library media specialist should periodically discuss student progress and evaluate lesson effectiveness.

COOPERATIVE PLANNING AND IMPLEMENTATION

Ideally, the instruction described in this book evolves through collaboration between teacher and library media specialist. It must involve more than a teacher's sending students to the library media center spontaneously and at the time of need. It must address the vague feelings of teachers and library media specialists that the other is to blame for a student's ineffective use of resources. Using the approach in this book, the teacher and library media specialist can anticipate common information search problems faced by all learners, and they can systematically design instruction. In this way, together they can ensure that students (1) are exposed to the entire search process, (2) can see the process modeled by different adults, and (3) can have opportunities for practice and further discovery without necessarily having the constraints of a formal research assignment, deadlines, and grades.

Some lessons included here are appropriate for large group instruction and can be cooperatively taught by the teacher and the library media specialist either in the classroom or in the library media center. Some lessons may be more effective when presented to small groups where individual comprehension can be closely monitored and hands-on experiences can be ensured. Thus, while looking together at lesson objectives, at their students, and at current instructional units, the teacher and library media specialist should create a plan that allows for flexibility with group size, frequency of lessons, and division of responsibility for direct instruction.

MASTERY OF SKILLS

Being successful in one's early efforts to locate information is a great motivation for self-directed learning. Young people must have positive experiences in order to gain the confidence needed to attempt more complex searches. As educators, our ultimate goal is to help students learn skills that they will use throughout their lives.

Chapter 1

Beginning the Search

INTRODUCTION

When any information source—card catalog, computer catalog, book index, periodical index, etc.—is examined, young people soon realize that they must identify the particular language of that information system if their search is to be successful. For example, since indexing vocabulary differs from source to source, the student needing information about frogs may find that information under **Frogs**, under **Amphibians**, under **Animals**, or even under **Pond Habitat** in different indexes in the same library. Trying to guess the terms used as index words can be very frustrating; yet, learning to be flexible and to adapt to the language used in any given resource or system is an essential skill for lifetime information literacy.

The lessons presented here assume that upper-elementary and middle-grade students have been exposed to the types, functions, and locations of various indexes. Depending upon their ages, earlier instruction, and experiences with library resources, additional lessons may need to be devised before students can benefit fully from the material presented here.

The three lessons in this chapter reinforce basic concepts of information problem-solving and introduce the new, fundamental vocabulary of search word strategies. It is important to assess the level of student understanding prior to any new teaching. This chapter begins with a discovery lesson presented in a nonthreatening, group-oriented game format. The library media specialist and teacher can observe individual behavior and adjust subsequent lessons according to the level of skill displayed by the students. The task and the time allowed for its completion must be balanced in order to optimize student success.

All lessons were designed for parallel teaching with the library media specialist giving the primary instruction. The teacher's presence during the lessons conducted in the media center is essential for classroom follow-up. The teacher also may observe previously unknown strengths and weaknesses in class members as well as offer insights about the students to the library media specialist.

STUDENT OBJECTIVES

1. The student will express information problem-solving as a thinking process that can be analyzed and refined.

2. The student will recognize that each information system uses its own retrieval language which may differ from others.

3. The student will identify five strategies for selecting subject search words when approaching information sources.

4. The student will demonstrate flexibility in using the five strategies for subject searching.

5. The student will verbalize the thinking process as a way of linking question with search strategy regardless of the source or format in which the information is presented.

LESSON 1 (DESCRIPTIVE): ASSESSING STUDENT SEARCH SKILLS

Lesson Objective

Prior to formal instruction in using search word strategies, students will demonstrate their present skills by locating facts in the library media center.

Description of the Activity

Fast Fact Take-Out: Info-to-Go is a game designed to assess general search skills of students in grade 4 or above. Partners are assigned. The pairs (call them "Short Order Searchers") are divided into three or four teams, depending on class size. Each pair is given a colorful, appealing picture of some object, person, or identifiable event of interest to the age group (e.g., sporting event, space shuttle, ballet dancer). The picture should have no label or caption. The object of the game is to locate in either a print or electronic source at least one interesting fact relevant to the picture's content. When time is called, the team having the most completed *Info-to-Go* cards in their *Fast Fact Take-Out* bag is the winner.

Materials Needed

Forty to fifty picture cards. These do not need to be uniform in size, color, etc. Magazines and publishers' catalogs are good sources of pictures that may be mounted and laminated if desired.

Info-to-Go cards for recording information.

Info-to-Go Card
Fast Fact Take-Out from the Media Center

Subject/Topic: _____

Fact found: _____

Source of information (title of source/page): _____

"Short Order Searchers" (Students' names): _____

Fast Fact Take-Out bags for collecting completed cards. A small paper bag similar to those used by fast food restaurants should be labeled for each team.

Directions for Playing

1. Partners examine their picture card, decide what topic or aspect to investigate, and discuss a plan of action (approximately one minute).

2. One pair at a time from each team uses any source in the library media center to locate information about their subject. If they cannot locate information, they return to their seats.

3. When information is found, each pair records the fact and source selected on an *Info-to-Go* card, reshelves the material used, and places the completed card in its team's *Fast Fact Take-Out* bag. They are given a new picture card, then return to their seats.

4. As in a relay, another pair from the team conducts its search. When all pairs have had a turn, they begin again.

5. The game continues for a predetermined amount of time (twenty minutes is suggested). When time is called, the team with the most *Info-to-Go* cards in its *Fast Fact Take-Out* bag is the winner.

6. As time allows, a few *Info-to-Go* cards should be pulled from the bags, and team members should be asked to explain briefly how they obtained their information.

Evaluation

The teacher and library media specialist should consider how the students performed. If the students showed a high degree of proficiency in conducting searches, only minimal teaching of search word strategies may be needed. Presenting the concepts in Lesson 2, however, is essential for developing a common vocabulary to use with students when discussing the problems that inevitably arise in subject searching.

Although this game serves as a pretest for instruction, it would be interesting to conduct the activity periodically in order to observe changes in searching behavior. In subsequent games, the initial task cards can be more structured than the open-ended subjects suggested by the picture cards (e.g., "Find the winner of the 1976 Baseball World Series").

LESSON 2 (NARRATIVE): SEARCH WORD STRATEGIES

Lesson Objective

The student will define five search word strategies.

Motivating Activity

[Show transparency 1.1]

What comes to mind when you look at this picture? (Note: Answers to questions in the narrative lessons will be italicized. *The brain or thinking probably will be suggested.*) Encourage comments. Have students consider the question of how thinking occurs. In our lesson today, we will be thinking about thinking. We practiced looking up information when we played *Fast Fact Take-Out*. Our object in the game was to find information fast! Now, we want to emphasize how we found those answers. We will be "tracking our thinking trails" or "thinking aloud." There is a fancy word for thinking about one's thinking. It is "metacognition." By thinking about the process we are using as we search for answers to questions, we can improve our skills for finding information. This applies to searching for information that satisfies personal interests as well as to research for a school assignment.

Presentation

We will use the words "search word strategies" to mean "our plan for finding answers to questions." This is how we begin our search—how we think of those words most likely to lead to information in an encyclopedia, an index, the card catalog, a computer catalog, or even in the yellow pages of the telephone directory! We will learn in our lesson today the five search word strategies that people commonly use.

People who create encyclopedias, books, computer databases, and indexes of any kind want their information to be organized and available to you, the reader. But they do not always use the same vocabulary to help you find the information you need. For example, if you wanted to find information about frogs, you might find it under **Frogs** in the library catalog, under **Amphibians** in an encyclopedia, and under **Animals of the Pond** in a large set of nature books. We must try to second-guess the people who designed these indexes. What words did they decide to use to indicate the information included in their material? Sometimes we will guess the correct word to look under; sometimes we won't. Sometimes we will think our source doesn't contain information on a subject when it actually does—we just haven't thought of the right index word. If we want to use the least amount of time in finding information, and have the most success with less frustration, we should have a plan, or strategy, for looking.

[Show transparency 1.2, revealing title only]

Here are five search word strategies that will help you use your time efficiently and be successful. Let's look at the first one.

[Show transparency 1.2, revealing strategy #1]

When you have a question such as, "What is a cyclone?" it is clear that the noun, **Cyclone**, is the keyword. That is the word you will look up first. You might find additional information about cyclones under **Storms** or **Weather**, but the first approach is to use the keyword itself.

If your question contains a double word, or a phrase, such as "Statue of Liberty," it is not always so obvious what to do. We are still using the keyword strategy, but which word do we look under? A good rule to remember is to look for the words in the order they appear in the phrase when it is a commonly used name. So in this case we look under **Statue of Liberty**. Do you think this would be true when looking up the **Golden Gate Bridge**? (*Yes.*)

It gets a little more complicated with names like "Mount St. Helens." In this case, try **St. Helens** first because "Mount" acts more like a title such as "Mr." or "Mrs."

Sometimes the keyword is understood, or implied, rather than actually stated as when asking, "Why do we celebrate March 17?" In this case, first try looking up **Patrick, St.**, since "Saint" is an honorific title. How would we look up "Valentine's Day"? Would it be smart to look both under **V** for **Valentine** and **S** for **Saint Valentine's**? (*Yes.*) In some sources, we may find "Saint" spelled out, and in some sources it may be abbreviated "St." but alphabetized as if it were spelled out. So be prepared to look several ways and figure out what the indexer decided to do even if you think it would have made more sense another way.

What is the keyword in the question, "In what year was Abraham Lincoln born"? Why do we use "Lincoln" and not "Abraham Lincoln"? Now, here is a rule we can almost always depend on: Look up people by their last name! So, when we look under **Lincoln** in most any resource, we will find that he was born in 1809.

> [Show transparency 1.2, revealing strategy #2]

Some questions require a little rethinking before you actually begin a search or when you are not finding what you expected. You may look up **Cars** as a search word in the library catalog and find that it is not used as a subject heading. At this point you could easily become discouraged. You might say to yourself: "That doesn't seem logical! Any school library media center would have at least one or two books about cars. What's wrong?" In this case, you did not think of the word the catalog actually uses as a subject heading for books about cars. What related word or synonym has the same meaning as "cars"? (*Automobiles.*) Using the term **Automobiles** should lead you to the materials.

Sometimes this related word strategy is also used in looking for information about a person who is commonly known by a nickname or a pen name. To find a biography of Johnny Appleseed, you may need to check under his real name, John Chapman, even though the encyclopedia entry may be under **Appleseed**. Remember, however, to look up **Chapman, John**. Dr. Seuss may be listed under **Seuss** in one source and under **Geisel, Theodor Seuss** in another. Using this second strategy—the related word strategy—requires a lot of flexibility in your thinking.

The library catalog is especially confusing because it seems to prefer unusual forms of words over more natural language. Who would think of using the term **Cookery** when you are looking for cookbooks? Or **Handicrafts** rather than just plain **Crafts**? But these are the accepted or official subject headings; until you figure them out, resources indexed this way may stay hidden from you.

To make it even more complicated, sometimes the preferred subject heading changes over time. For example, in today's society, we often use the term **Blacks** or **Black Americans**, but many people prefer the term **African Americans**. Not so long ago, the indexing term used was **Negroes**. This is a term used less often today. The same is true for **Afro-Americans**, yet some resources may still be indexed with these words. Once a resource has been entered into the library catalog under a particular term, it is not likely to be changed there. You can see, then, that we need to keep all possible related words in mind and try several to make certain we find as much useful material as possible.

> [Show transparency 1.2, reveal strategy #3]

Often the specific subject you are looking for may not have much written about it. It may be treated as part of a larger subject. Information about Siamese cats might be included in a book about cats. You may need to move from your particular topic to a broader word that includes it. This broader search word strategy would apply when trying to find out about veins and arteries. You might look up **Blood**, or **Heart**, or **Circulatory System**. Here is another example: You probably won't be successful in looking up the phrase **Fruits and Vegetables** if you are studying this standard food group. Nor will **Basic Food Groups** work. You will have to move up one level in the hierarchy to a broader term and try **Diet** or **Nutrition**. Tell me how you would move from the term **Miniature Poodle** to a broader term. (*Dog.*) **Boa Constrictor**? (*Snake,* not *Reptile.*)

> [Show transparency 1.2, revealing strategy #4]

Sometimes the term that comes to mind is actually too broad, and you need to narrow it, or move down a level in the hierarchy. If you need information on Civil War battles, you do not want to begin your search with **United States History**. If you know the name of a famous battle, such as Gettysburg, try looking for that specific word. Here are other examples. To find information about astronauts, you don't need to start with **Space Exploration**, just begin with **Astronauts**. Try **Air Pollution** first, not **Pollution**, if you need information on the impact of the Clean Air Act. Look directly under **Lincoln**, not **U.S. Presidents**, if you want to know about his campaign for the presidency. Remember, you may need one word to locate an information source in the library catalog and a different word when you are using the index in the book that you have found.

> [Show transparency 1.2, revealing strategy #5]

Many times our questions are much more complicated than the examples thus far. Successful searching requires that you consider how subjects overlap through time and place, through historical events, and through the relationship of individuals. This search word strategy of overlapping subjects requires that you think of the relationship of broad categories that might include, or relate to, your specific topic of interest.

Let's look at two examples. If you need information about the invention of the automobile, there are several possibilities. You can look up **Automobile History**, **Henry Ford**, or **Inventions of the 20th Century**.

How might you use overlapping subjects in locating information about Mary McLeod Bethune? You can consider such topics as **Black Americans**, **Women**, **South Carolinians**, **Teachers**, and **Educators**, as well as using her own name as an indexing term.

Sometimes subjects overlap and there may be commonly accepted phrases for indexing that combine these topics. **Charts and Diagrams**, and **Mystery and Detective Stories** illustrate such a practice. Often you will find these phrases used in library catalog subject headings and in magazine indexes.

Discussion

We have considered five search word strategies. Is there one right strategy for each question you may have? (*No; there are some words that are more likely to be successful than others. Some questions may take more than a single strategy. You may have to move back and forth between strategies.*)

Does one particular search word strategy work in all information sources? (*No; library catalogs, indexes, books, computer databases, etc. very often differ in the terminology used.*)

What should we do if our search is not successful? (*Be flexible and try another approach; ask questions; ask for suggestions of other indexing words that we might try.*)

Guided Practice

> [Use transparency 1.3, revealing one question at a time]

We will look at some questions and discuss the basis on which we decide the search word strategy to use. In this exercise, there can be more than one correct answer. As a class, we will decide on the word that might be the best choice for a first try; that is, the term that will provide the quickest and most likely success. In a later class session you will actually check resources to see what you find. [Discuss the questions; allow for different opinions.]

Check for Student Understanding

In summary, let's hear the definition of "search word strategy" as you understand it. (*A plan for approaching an information source.*) Can you name the five strategies people most commonly use? (*Keyword, related word or synonym, broader word, narrower word, overlapping subjects.*)

Closure

In summary, let's review the meaning of each of the five search word strategies.

> [Show transparency 1.2, asking students for the definitions]

LESSON 3 (NARRATIVE): PLAN BEFORE YOU LEAP

Lesson Objective

The student will compare different search word strategies to determine how to be successful when using a variety of information sources.

Materials Needed

Each student will need an Activity Card #1.

Activity Card #1
Getting Started with Subject Searching

Your question: _____

Your plan of action (Think of which search word strategy, or strategies, might work? Write the terms you will try beside the strategy):

 Keyword _____

 Related Word (Synonym) _____

 Broader Word (Larger Subject) _____

 Narrower Word (Smaller subject) _____

 Overlapping Words and Phrases _____

Source of information (List of title[s] of any material examined): _____

Evaluation of the process (Which search word strategy led to the information?): _____

This activity requires considerable preplanning and familiarity with resources by the instructor. From transparency 1.3 in Lesson 2 of this chapter, select questions to be assigned to groups and record them along with notes on where the answers may be found. Several answer sources should be provided to each group when they are doing the activity. To facilitate planning, use a form such as follows:

Activity #1 Planning Guide
Questions and Their Answer Sources

Topic: *Old Faithful*

The World Book Encyclopedia (1994), vol. 14 (N-O). No article "Old Faithful." See reference to **Wyoming** (color picture); **Yellowstone National Park.**

The World Book Encyclopedia (1994), vol. 21 (W-Z). **Wyoming** article has picture of Old Faithful.

The World Book Encyclopedia (1994), vol. 21 (W-Z). **Yellowstone National Park** article mentions it.

Webster's New Geographical Dictionary (Springfield, Massachusetts: G. & C. Merriam, 1980). Entry under **Old Faithful** with information.

Jensen, Paul. *National Parks: A Guide to the National Parks and Monuments of the United States* (New York: Golden Press, 1964). Index entries under both **Old** and **Geysers.**

Thomson, Peter, *Wonders of Our National Parks.* (New York: Dodd, 1961). No index entry under **Old**; indexed under **Geysers.**

Motivating activity

In our last lesson, we learned five common search word strategies. Let's see how many you can recall. (*Keyword, related word or synonym, broader word, narrower word, overlapping subjects.*)

[Write these on a blank transparency or the chalkboard as they are named.]

Presentation

[Reshow transparency 1.2]

This is our original list of search word strategies. See how well you did in remembering. Now we want to take another look at the questions presented in our last lesson and spend some time discussing the most likely source in which to look up the answers. You already know that information about a subject can be found in a variety of places. Sometimes the amount of information varies. Sometimes the reading level makes one source difficult to use, but in another source you may think that an author is talking down to you. Evaluating what you read and deciding whether it is useful is essential, but today we will not be talking so much about analyzing the content as we will be considering where to look and which search words to use.

[Reshow transparency 1.3]

Most of these questions are simple and direct. An encyclopedia—or even a dictionary—may provide all the needed information. Encyclopedias give a general overview of a topic and are often the place to start before looking for an entire book on the subject. Increasing your background information on a topic helps you to think more easily of related words and overlapping subjects. Relying only on encyclopedias is something you want to avoid, however, because the information is generally not fully developed.

Guided Practice

[Distribute Activity Card #1]

Each of you, working independently, is to complete this card, "Getting Started with Subject Searching." All the students in your group [by tables or by some other grouping] have the same question, so you will share the materials that have already been pulled. After your activity card's "plan of action" has been filled in, each person will take a different resource and examine it, looking for the answer. Make notes on your card about which search strategies work and which don't. Problems may be discussed with members of the group. Be ready to share your results with the whole class as time allows.

Closure

In our everyday lives, we are always coming across things we don't understand or that we want to learn more about. We all have asked other people to tell us what they know about a particular subject. This is an acceptable way to learn. There may come a day, however, when you yell, "Hey, Mom, what does *so-and-so* mean?" and she answers, "Look it up!" Or, you come to the library media center, and no one is there at the moment to help you. Then what? You discover that you really didn't need help after all—you found what you were looking for by yourself! You thought through the question, you thought through the possible places to look, and you thought through the search word strategies to use. Gaining independence in this way lets you take charge of your own learning.

TRANSPARENCY 1.1

SEARCH WORD STRATEGIES

1. **KEYWORD**

2. **RELATED WORD (SYNONYM)**

3. **BROADER WORD (LARGER SUBJECT)**

4. **NARROWER WORD (SMALLER SUBJECT)**

5. **OVERLAPPING SUBJECT WORDS**

TRANSPARENCY 1.2

SELECTING SEARCH WORD STRATEGIES

QUESTION	*SEARCH WORD STRATEGIES*
1. Find out about some common pets.	_____
2. Where is "Old Faithful"?	_____
3. Make a list of animals without backbones.	_____
4. Who was Buffalo Bill?	_____
5. What are some interesting animals from Africa?	_____
6. What color is a chickadee?	_____
7. What are the names of two Spanish explorers?	_____
8. Find out about mudpuppies.	_____
9. Find three facts about the War Between the States.	_____
10. Find some information on Christmas cards.	_____

— **Answer Sheet** —

SELECTING SEARCH WORD STRATEGIES

QUESTION	*SEARCH WORD STRATEGIES*
1. **Find out about some common pets.**	• Pets (keyword); Animals (broader); Pets we know, e.g., dogs, gerbils, etc. (narrower)
2. **Where is "Old Faithful"?**	• Old Faithful (keyword); Yellowstone National Park (broader); Geysers (broader); Geysers—Wyoming or Geysers—U.S. (overlapping subjects); National Parks (broader)
3. **Make a list of animals without backbones.**	• Invertebrates (synonym); animals (broader—long shot)
4. **Who was Buffalo Bill?**	• Buffalo Bill (keyword); Cody, William (synonym); cowboys (broader)
5. **What are some interesting animals from Africa?**	• Animals—Africa (overlapping); Africa—animals (overlapping); Animals *or* Africa (broader); an animal we know comes from Africa (narrower)
6. **What color is a chickadee?**	• Chickadee (keyword); birds (broader)
7. **What are the names of two Spanish explorers?**	• Explorers, Spanish (overlapping); Spain—explorers (overlapping); Spain—History *or* Explorers (broader)
8. **Find out about mudpuppies.**	• salamander (synonym); mudpuppies (keyword); amphibian (broader)
9. **Find three facts about the War Between the States.**	• U.S.—History—Civil War (overlapping/synonym); Civil war (keyword/broader); U.S. History (broader); wars (broader)
10. **Find some information on Christmas cards.**	• Christmas cards (overlapping); greeting cards (broader); Christmas customs (broader/overlapping); holidays, handicrafts (overlapping)

Chapter 2

Searching by Subject in the Library Catalog

INTRODUCTION

The library catalog can be a powerful teaching tool. Hands-on interaction transforms the abstractions of search word strategies into concrete experiences for students. Investigating one's own library media center collection and examining the specific indexing terminology that makes it accessible reinforces search concepts in a meaningful way.

Card catalogs are still the norm in many schools across the nation. They can have instructional value in teaching the alphabetizing of files, and can serve as a tangible representation of the resource collection. Instructors who have one of the all-too-common card catalog "relics" where currency and accuracy are in doubt are advised to assess the state of cards that have to do with a particular lesson's content; make cross-references, if needed, for clarity; target small sections of the catalog to correct or update; and leave the rest of the catalog alone.

Automated catalogs provide great impetus for student searching. Today's video-age students seem to catch on quickly to online catalog designs and are freed to concentrate on their primary search task rather than on an intermediate one of turning through alphabetized cards.

Whatever system is in place in the reader's own library media center, students will benefit from a systematic exposure to the thinking process required to gain access to the indexing system, and thus to the resources for information.

Again, as in Chapter 1, the following lessons begin with students' demonstrating their current understanding. They first are asked to assume the indexer's, or cataloger's, role. Then they examine their own library catalog to discover subject cataloging patterns. Lesson 3 focuses on books containing science activities and experiments, but other themes (such as the environment) could be substituted using this same lesson format. The three lessons that center on an investigation of the American Pilgrims could be adapted as models for such curriculum units as the solar system, space exploration, or pioneers and westward expansion.

Deciding on an appropriate topic occurs when the teacher and library media specialist plan together. Current classroom instruction will most often suggest a lesson's content. Since hands-on examination of materials is essential to mastery of the lesson objectives, the collection must be able to support such activity. Also, no matter what final student assignment is made by the teacher, the initial focus of these lessons is on thinking about the process.

STUDENT OBJECTIVES

1. The student will recognize the purpose of and the variation in subject entries in the library catalog.

2. The student will relate the terminology and word order of subject cataloging to search word strategies.

3. The student will use graphic organizers to show the relationship of search terms.

4. The student will use a variety of means to expand subject access in the library catalog.

LESSON 1 (DESCRIPTIVE): FINDING THE COMMON DENOMINATOR

Lesson Objective

Students will examine a selection of books, determine their subject content, and assign descriptive terms arrived at through group consensus.

Materials Needed

A minimum of three books per student is suggested. The library media specialist or teacher should give careful attention to including at each table, or for each group, examples of the following: fiction and nonfiction books; single-word titles having the same word as their subjects; books in which the first word of the title is not the subject word; books in which the subject word does not appear in the title at all; books that give equal treatment to more than one subject. (Books on the same subject should be placed at more than one table.) Topics may include subjects under current investigation, or selection may be based on subjects of general interest to the age level.

Motivating Activity

> [Introduce the lesson briefly using the following script as a guide;
> allow the students to discover the library cataloger's task on their own
> rather than telling them before they engage in the activity.]

Whenever you are lost in reading a good book, someone is bound to notice and ask what it's about. You might answer with one word—"Rocks"—or a phrase—"mind benders and things"—or a sentence—"It's a mystery story about some lost kids"—or a two-page book report—if your teacher is doing the asking! What your answer does, in a way, is to assign your book to a subject category. In our activity, you will be deciding on appropriate words to describe the general topic of some books I have selected. You will think of several terms that could describe the individual titles; your group should then decide on some "common denominator" terms for books that are similar.

Description of the Activity

"Finding the Common Denominator" is a cooperative group discovery activity that requires students to think of simple, descriptive terms to represent the subject content of books and thus creates an awareness of the cataloger's task. A beginning understanding of the Dewey decimal classification could be helpful but is not essential in order for students to perform this activity well.

1. Ask students to examine the books placed at their tables. Encourage discussion; review guidelines for a cooperative activity in order to make sure all are heard.

2. Ask that books be sorted and that each group arrive at consensus on the words best describing the subjects they contain. Subject words should be written on note cards by a group member.

3. Ask groups to share their results with the class. As soon as a subject is presented with its representative books, any other group having a similar subject should contribute its findings. Point out any varia-

tion in subject terminology used by the different groups. Have students give the reasoning for their selection of terms.

4. Point out books that could fit into more than one subject category. Note those books which required the addition of the word "fiction" to the subject for clarification.

Evaluation

The media specialist and teacher should observe the students working cooperatively and not intervene prematurely with suggestions of subject terminology. Attention should be given to the manner in which students select and refine terms. In subsequent lessons it may be pointed out how similar their choices are to the real or authorized subject headings found in the library catalog.

LESSON 2 (NARRATIVE): UNDERSTANDING SUBJECT CATALOGING

Lesson Objective

The student will be introduced to basic subject heading patterns in library catalogs and will relate them to search word strategies for locating subject entries.

Prerequisite Skills

Students should have had prior instruction and experience with their own library catalog and be able to distinguish among types of catalog card entries or basic search options—author, title, and subject.

Motivating Activity

You are now familiar with five basic search word strategies—keyword, related word, broader word, narrower word, and overlapping subjects. You also have had the experience of professional catalogers in trying to determine the best indexing terms for a particular book. Now we will concentrate on using these strategies when searching for books in our collection—books that might contain the information we want. What is our library media center's index to its book collection? Where do we go to find out which books on particular subjects are here for us to use? (*The catalog.*)

> [Show transparency 2.1 or 2.2, depending on the library catalog in use]

Yes, our library catalog serves as an index to all the materials that we see around us. If we become familiar with basic subject heading patterns in our [card *or* online] catalog; we will have a better understanding of why our search word strategies help us in matching our search terminology with the words that actually appear in the catalog. For a few minutes I want you to examine some of the subject entries in the catalog and see what generalizations you can make—that is, what patterns you notice.

> [For card catalog users: Each student is provided with a drawer from the card catalog
> and asked to write examples of the following: single words used as subject headings,
> multiple words as headings, and headings in which hyphens or commas occur.
> If the instructor uses the term "subject subdivision," a brief explanation should be given.]

> [For automated catalog users: Students are asked to view a picture of a subject
> screen list (transparency 2.3) and note the following:
> single words used as subject headings, multiple words as headings,
> and headings in which hyphens or commas occur.]

Presentation

You may be remembering the lesson in which you sorted some books into categories and identified their subjects. Just now in your investigation of subject headings appearing in the library catalog, you may have wondered who actually decided on this particular list of subject words used. You may think that I

assigned the headings to each of our books indexed, but I did not. Libraries tend to use one or more subject authorities: published lists of currently accepted library terminology to be used in subject cataloging of materials. These lists provide a common way of describing books in libraries across the country. *Sears List of Subject Headings,* the *Library of Congress Subject Headings,* and *Headings for Children's Materials* (Fountain 1993) are examples of such authorities.

Now, let's return to our subject search word strategies and see how they help us locate useful subject entries.

[Show transparency 2.4]

If we want a book about dogs, we use a keyword search and look for the entry **Dog**. By adding the word **Fiction** after **Dog**, we are limiting our search by being more specific, but it is still a keyword search—we are just saying that we want an imaginary account, not an informational book about dogs. This picture shows us part of a subject list from an online catalog and an example of a dog story, *Jim Ugly,* from the title listing under **Dogs—Fiction**.

[Show transparency 2.5]

These are three subject cards as they appear in a card catalog. Notice the nonfiction book assigned the heading **Dogs**. Rylant's book is cataloged under **Dogs—Fiction**. Until about 1965, the subdivision **stories** was used in a subject heading to indicate fiction. So The *Disappearing Dog Trick,* which has a copyright date of 1963 uses the subdivision **Stories** following the word **Dogs**. You can see why it may be important to check both ways in the library catalog.

Sometimes all the books about a topic cannot be found under a single subject heading. Think of how the related term strategy could apply. For example, in our card catalog, both subject headings **Songs** and **Carols** are used for **Christmas Carols**. Both **Astronaut** and **Space Flight** are used for manned space flight. Again, it would be wise to check more than one term.

[Show transparency 2.6]

Information about Black Americans can be found under **Blacks** or **Negroes**.

[Show transparency 2.7]

You will find that some library catalogs have added **Afro-Americans** because that has been the standard term in the subject authority for a time. You can see that library terminology does not necessarily reflect current cultural usage. Remember, though, that books with older copyright dates may have been indexed using those terms which we consider outdated, so look under as many words as you can think of when you use the library catalog.

Here are examples from another topic. The subject **Pollution** can be found under that term or under such narrower, more specific terms as **Air—Pollution** or **Water—Pollution**. You would not expect to find a subject entry in the library catalog under **Smokestack Emissions Control**—that would be just too specific—but you might find an entry under **Acid Rain**. **Air Pollution** would be the appropriate, midlevel entry point into the catalog for both those subjects. Then you could try the more specific terms.

Once you have in hand a book on air pollution, however, "smokestacks" as well as "acid rain" might be listed in its index. This is an important concept to learn. Subject words for getting to a book through the library catalog may differ from subject words for finding specific content *within* that book!

[Transparencies 2.8 and 2.9 relate primarily to a card catalog; omit discussion or modify according to an online catalog's provision for cross-references.]

[Show transparency 2.8]

The library catalog may give clues to help you continue your search. Cross-references, either printed on separate cards or in the subject heading list, lead you to collections of poetry.

[Show transparency 2.9]

Notice, too, the variety of terms used for collections of poetry. The "collected works" are anthologies, which means that they contain poems by several poets.

Sometimes you must work a little harder for a clue to help you know where to look. If you want a fiction book with an early American setting similar to *Little House in the Big Woods* by Laura Ingalls Wilder, it is difficult to think of what subject to call it. A good idea is to look up either Wilder or the title and notice the tracings, or subject headings, printed at the bottom of the card [*or* card display].

[Show transparency 2.10]

You might never have thought of **Frontier and Pioneer Life—Fiction**, yet using that phrase leads you to many other books in the collection.

[Show transparency 2.11]

The book by Conrad is an example. Notice that this book has three other subject entries in addition to **Frontier and Pioneer Life—Fiction**. Looking at these tracings along with the summary note gives us a good idea of the story.

There are times when the library catalog uses other really curious, seemingly obscure, words for subject headings. As we discussed earlier, who would think of looking up the word **Handicrafts** when you want a book about crafts? But **Handicrafts** is the accepted term.

[Show transparency 2.12]

Notice in the tracings that this book on making decorations is not listed under the subject word **Decorations**, but rather under the more specific words, **Holiday Decorations** and **Gifts**. It also can be found under the general heading **Handicrafts**.

Libraries may keep a copy of their printed subject authority file, or thesaurus, near the catalog for

anyone wanting to scan it for help in determining search terminology and in figuring out the accepted word order used for headings.

Check for Student Understanding

Do you think subjects are only nouns? (*No.*) Have you come across a proper noun as a subject entry? (*Yes.*) What about words like **swimming** or **backpacking**? Could books be listed under these subjects? (*Yes.*)

Closure

Since the catalog is the basic index to our library media center's resources, we must use appropriate search word strategies to help us gain access to materials in the collection. Increasing our understanding of how the subject headings usually appear can aid us in selecting appropriate terms. Remember tips listed in transparency 2.13 when thinking of subject words to try.

[Show transparency 2.13]

LESSON 3 (NARRATIVE): GETTING UNSTUCK—ADDING SEARCH WORDS

Lesson Objective

Using the library catalog, the student will locate books that seem likely to contain science activities and projects.

Materials Needed

Gather and display a selection of science project books that illustrate variation in subject cataloging—one for each student or pair of students.

Motivating Activity

As we begin today, I want you to recall your experiences at science fair time! [Prompt with these questions.] What happened when you began looking for possible projects? How did you get started? Did you use any of the science activity books in our collection for ideas? Were they hard to find? In this lesson we want to apply what we have learned about search word strategies and subject cataloging, add a few tips for getting unstuck, and then see if we can increase our success in locating books.

Presentation

Some people would think it reasonable to use the keyword (or phrase) **Science Projects** when checking the library catalog for books containing science project ideas. Until the most recent edition of the subject authority was published, you would not have been able to locate information under that subject heading. So, to find books containing science project ideas, you had to do a little detective work in order to discover the cataloger's word. If you tried the word **Projects** as a subject, that didn't work either. But if you checked the library catalog for a title beginning with the words **Science Projects**, it gave you an entry point and you might have found a book such as *Science Projects and Activities* by Challand.

[Show transparency 2.14]

By looking at the tracings at the bottom of its title card [*or* card display], you will notice that this book has two subject entries, **Science—Experiments**, and **Experiments**. That is what you were hoping to find out! When you check for listings under these terms, you will find many other books containing possible science projects.

The library catalog you are using may have gone an extra step and provided its users with cross-references and thereby broadened the search options.

[Show transparency 2.15]

As you look through the listing of titles under the subject **Experiments**, the tracings may continue to give you other leads. Notice that Barrow's book is entered also under **Rocks—Experiments** and that Gutnik's book, *Simple Electrical Devices*, also has additional subject headings, one of which is **Electricity—Experiments**. You might wonder if this word order (in which the category of "Science" is given first then followed by the term "Experiments") would pertain to other areas of science as well. If you had

looked up chemistry, you would have found a subject entry for **Chemistry—Experiments**. This is true for **Plants—Experiments**, **Magnetism—Experiments**, etc. So, by inferring a word order pattern and checking to see if you are correct, you have expanded your possibilities for finding interesting and useful material. With this pattern in mind, can someone suggest why the Gardner book used only the headings **Science—Experiments** and **Experiments**? (*It contains experiments from many different fields of science.*)

Has anyone noticed that the call numbers—or Dewey classification numbers—for these three books are different? That is because each of the books focuses on a different topic. One is about rocks, so it has the Dewey classification 550.87. One is about electricity so it has the Dewey classificatiom 621.3. The book that contains experiments on a wide variety of subjects is assigned the general Dewey number 507. What do these books have in common? (*They all include experiments.*) So the subject heading pulls them together for us in the library catalog, even though they physically sit on different shelves.

Guided Practice

[Distribute Worksheet 2A]

We will examine some science books now that have been selected from the shelves for you. You are to predict under what subject heading they would have been found in the library catalog had I asked you to look for them. When you have completed the worksheet, you are to verify your prediction by actually checking in the catalog under either your book's title or its author. Be ready to share with the class what you find by looking at the tracings for your book.

[Allow time for completion of the activity; students will finish at different rates.
Provide additional science project resources for browsing;
science-related periodicals or vertical file materials are suggested.]

Check for Student Understanding

Now that you have shared your own predictions and verifications of headings, I want to tell you about a very helpful bit of information to remember in future searches. Had I told you before the activity, someone might have been tempted to do less thinking! But, here is the tip: In today's lesson, if you have been examining a book that was published after 1971, chances are it contains something called "Cataloging-in-Publication." Publishing companies send their galleys, or what we might call the final rough drafts, of their forthcoming books to the Library of Congress to have the cataloging done before the actual publication of the book. This data, then, can be printed right inside the book. Turn to the verso, or back side, of the title page in your book and you may find what looks like a miniature [catalog card *or* card display]. Could someone explain how this information might be helpful? (*It lists the book's subject headings, which may provide suggestions for other searches.*)

Closure

You now realize that a book's content may require it to be assigned more than one subject heading. One to three headings have traditionally been assigned by catalogers. The Dewey classification numbers may also vary for books that use the same subject terms, as we have seen. The intent of the person who made all these decisions about a particular title was to describe the subject content of the book as clearly and

as fully as possible using an established subject authority, and to have the book placed on the library shelves in physical proximity to other materials of a similar subject. If you get stuck determining the cataloger's terms, just remember the tips in this transparency.

[Show transparency 2.16]

The four lessons that follow were designed to be taught on consecutive days to upper-elementary students involved in a colonial America unit. Other topics could be substituted, and the narrative format that follows used as a general model.

LESSON 4 (NARRATIVE): PASS THE PILGRIMS, PLEASE

Lesson Objective

The student will demonstrate the cataloger's task of examining books and assigning subject headings to them.

Materials Needed

Gather and display a selection of pictures and books with a Pilgrim and Thanksgiving theme; include titles on colonial America in which the Pilgrim information is not immediately obvious. Students will work in pairs on a book and will use the same book in Lesson 7.

Motivating Activity

> [Show briefly a variety of pictures of Pilgrims and Thanksgiving scenes.]

At this time of year we begin to see reminders of the Pilgrims all around us. Thanksgiving decorations are in stores and classrooms. In your social studies lessons, you have begun the study of early American settlements. Think for a minute about your introduction to this topic, from preschool days until now. [Discuss briefly.]

Presentation

All the fragments of our knowledge can be useful as we combine them into search word strategies for locating more information. In this lesson we are still looking only at library books, and these have been pulled for you to help us get started more quickly. You will be examining books and noting both content and organization: what information the book contains and how it is presented.

Guided Practice

> [Distribute Worksheet 2B]

You are to work in pairs examining a book and completing Part 1 of the worksheet "Finding Out About the Pilgrims."

> [Allow time; offer assistance as needed]

Closure

To make judgments about subject entry assignments for a book, the cataloger or indexer must do what each of you has been doing—look carefully at the publication in order to describe its content and coverage. In our next lesson you will apply some likely indexing terms and see how well they match the real thing.

LESSON 5 (NARRATIVE): THE RELATIONSHIP OF TERMS—PILGRIM, PLACE, THING

Lesson Objective

The student will identify appropriate terms for a subject search and graphically represent their relationship.

Motivating Activity

[Show transparency 2.17]

We will use a "Brainstorm Box" to record words that you associate with the topic of Pilgrims and the first Thanksgiving. Think of places, dates, and the names of individuals. You can probably think of lots of these because of your work in our last lesson and because of what you are studying in class. If you have your social studies textbook with you, it's okay to skim through the chapter on early colonial America, noticing especially section headings and highlighted words. That is an excellent way to get a lot of terms to examine and to select for a search. I want you to recall words and ideas that I will write on the transparency [or the chalkboard]. Notice that what one person says may jar your memory and suggest other words to you. This is the beauty of brainstorming! [Depending on the number of words suggested, the instructor may wish to record all the terms, then go back and eliminate unlikely words or phrases before continuing.]

Presentation

We will see some copies of cards from the library catalog to find out which of the terms you suggested are actually used as subject entries. Remember, because the accepted or preferred subject words and phrases have changed over time, we cannot expect all the books on a topic to be indexed the same. Remember, too, that some of the words that we collected in the Brainstorm Box will not be used in the library catalog but may be used in the index of a particular book.

First, using **Pilgrim** as a keyword search strategy we find some variation of that term in our library catalog. There are only a few older books listed under the single word **Pilgrims**. A few more titles are listed under **Pilgrim Fathers**! Is that a term you remember from your reading to this point?

The most current subject entry, as we find when we look at the copyright dates of the books, appears to be **Pilgrims (New England Colonists)**.

[Show transparency 2.18]

Remember, we can check our subject authority to locate the currently accepted terminology, but using only those headings does not guarantee that we will find all the titles in a particular library's collection. So we must be flexible.

Now, using another search word strategy, we can choose a narrower term for our search.

[Show transparency 2.19]

We might think of **Thanksgiving**, or more specifically, **Thanksgiving Day**. Locating that subject in the library catalog, we find both a book in the history section (Dewey number 974.4) and a biography of

Squanto (B). By adding the term **Fiction** (or **Stories**) to our search, we are led to the holiday book collection as well (Dewey number 394.26).

Sometimes in the early stages of a search, it helps to draw a kind of diagram, or picture, of how the subject terms are related. This visual representation helps those of us who are visual learners.

[Show transparency 2.20]

If we put the broad, more general topic of **Pilgrims** in a large outside circle, we can add **Thanksgiving Day** to the smaller circle inside to represent it as a narrower topic.

Guided Practice

Now, think of another narrower term that has to do directly with Pilgrims. Draw a large circle on a piece of paper and label it **Pilgrims** just as we did. Then in a smaller circle inside, write the word you thought of. The narrower term goes inside the larger term. [Ask students to share their terms. Write them on the transparency or chalkboard. Responses might include **Mayflower**, **Plymouth Plantation**, **William Bradford**, etc.] What we have just created is a graphic organizer. We used the circle inside a circle to draw a picture of the relationship of terms. That's what "graphic" means—a picture or drawing.

You may be familiar with another way to picture word connections, and that is by using a graphic web.

[Show transparency 2.21]

This can get very messy as a drawing, but it allows you to put a lot of different terms in at one time and think of their relationships. It is interesting that what we are drawing is actually what our brains are doing when we make mental connections.

Check for Student Understanding

How can a Brainstorm Box be helpful? Give an example of how subject headings on the topic of Pilgrims have changed over the years. How can a graphic drawing like those we did be useful?

Closure

Before diving too quickly into a search of the library catalog, stop to think of the basic knowledge you have about the subject. Remember these tips.

[Show transparency 2.22]

Keep considering the relationship of terms as you select and try out different search word strategies.

LESSON 6 (NARRATIVE): PICTURE THIS PILGRIM SEARCH

Lesson Objective

The student will graphically represent related terms, broader terms, and overlapping subjects in order to develop subject search approaches.

Motivating Activity

We have seen how using keywords or narrower terms have been successful search word strategies for our library catalog. We now will look at searching with related terms, broader terms, and overlapping subjects.

Presentation

In browsing through books, you may have come across the word "Separatists" and realized it referred to Pilgrims. Even if we do not find this related term used as a subject entry in the library catalog, we may find it useful later on as we search within reference books or other indexes, so we should keep it in mind.

As we are considering related terms, let's look again at the Sewall book.

[Reshow transparency 2.18]

This spelling of Plimoth is different from the more common spelling. Noticing variant spellings can be very important as you get deeper into research.

Next, we will think of broader terms we could use in searching the library catalog. We can represent these terms graphically just as we did with keyword and narrower terms.

[Show transparency 2.23]

If we add an even larger circle around **Pilgrims** and **Thanksgiving Day**, what can we label it? [Encourage **Massachusetts** as a response.]

[Show transparency 2.24]

Look at how our library catalog actually lists such a subject entry. Notice that the Weisgard book could have also been found under **Pilgrim Fathers** and the Sewall book under the newer subject heading form.

We can even go one level broader and consider United States history because it includes Massachusetts history.

[Show transparency 2.25]

Remember, if you looked under **American History**, you would not find a listing. **United States** is the preferred term, yet notice that it is written as an abbreviation! There is just so much to remember, isn't there? No wonder even adults get frustrated when using catalogs and indexes! [Instructors must be sure to explain the filing rules used for the term **United States** in their own library catalogs.]

Let's examine how the library catalog combines words in subject headings. If U.S. history is considered as one subject and the colonial period as another, do we not have overlapping subjects?

Again, we can see this relationship of terms by using a drawing.

<div style="border:1px solid black;padding:10px;display:inline-block;">[Show transparency 2.26]</div>

Do you recognize this particular type of graphic representation? Yes, it is called a Venn diagram and uses the overlapping circles.

In one circle we will write **Massachusetts**. In the other circle we will write **Colonial Period**. In the gray area where these two subjects overlap, we will write **Pilgrims**. What we have really done is to overlap a place—**Massachusetts**—and a particular time of history—the **Colonial Period**. That gave us **Pilgrims** as a particular topic within two much larger topics.

We can do the same thing with an idea. Take the idea **Religious Freedom** and overlap it with the **Colonial Period** again, and we have **Pilgrims** appearing in the gray area.

If we overlap **Thanksgiving Day** and **Indians of North America**, whose name will we find? (*Squanto*.) So, if we were gathering material on Squanto, this thinking exercise could give us some leads to a variety of sources that we would not discover just by using his name in the library catalog. We are reminded to look at books on Native Americans as well as accounts of the first Thanksgiving feast.

Guided Practice

<div style="border:1px solid black;padding:10px;display:inline-block;">[Distribute Worksheet 2C]</div>

This activity will help you see the relationship between some of the words we have mentioned and a few new terms. Work independently on this sheet, and let's see where your thinking leads you. Then we will compare your ideas with what others thought.

Check for Student Understanding

If I remind you that our three circles go from general to specific, which circle contains the most general term? (*The outer circle.*) Which circle contains the most specific? (*The inner circle.*) Look at Part 2 of the worksheet. What does the gray area represent? (*The area of overlap between subjects.*)
[Allow time for worksheet completion and group sharing.]

Closure

Thinking about the relationship of related words, broader words, and overlapping subjects can be very helpful in selecting terms for searching in the library catalog and in other reference sources.

LESSON 7 (NARRATIVE): COMING TO TERMS WITH THE LIBRARY CATALOG—PILGRIMS FOUND

Lesson Objective

Using the library catalog, students will compare their predictions of indexing terms with subject entries for specific books.

Motivating Activity

Working with your partner, you can complete your examination of the book you were assigned, then locate it in the library catalog to see how your prediction turned out. In a way, this is working backward since you already have the book. The point is; Could you have found it by yourself using what you have learned about subject indexing?

Guided Practice and Presentation

[Redistribute Worksheet 2B]

Using the same book as before, mark Part 2 of your worksheet with your predictions, then indicate what you actually find in the library catalog. Be ready to share this with the class. While everyone is completing the activity, you and your partner may gather books in addition to the one pulled for you if you are certain that they contain substantial information on Pilgrims. Let's see if your detective skills have increased after all our discussion.

[Allow time for completion of task]

[Show transparency 2.27; be certain that the list reflects your library's collection and catalog headings.]

Here is a list of subject entries found in our library catalog. As you share your findings with the class, we will notice which subject entries are more frequently used and which words you thought would have made good indexing terms but were not found in the catalog.

Closure

Using all five of the search word strategies will provide subject access through the library catalog to the actual books on the library shelves. Of course this does not mean the task is over—the effort to extract and evaluate the information within a source is basic to any search—but your ability to locate potential sources will continue to increase. Keep thinking, be patient, learn through trial and error. All this will lead to successful searching in any library catalog.

THE CARD CATALOG

TRANSPARENCY 2.1

An Online Catalog

```
Subject
─────────────────────────────────────────────
Revere, Paul, 1735-1818
Revere, Paul, 1735-1818--Poetry
Rhinoceros
Rhinoceros--Fiction
Rhode Island
Rhode Island--Fiction
Rhythm
Riddles
Riley, James Whitcomb, 1849-1916
Rio Grande
Ripken, Cal, 1960-
Rivera, Diego, 1886-1957
Rivers
Rivers--South Carolina
```

Reprinted with permission from Winnebago Software Company.

Subject

Dogs
Dogs in art
Dogs--Cartoons and caricatures
Dogs--Fiction
Dogs--Habits and behavior
Dogs--Poetry
Dogs--Training
Dogs--Training--Fiction
Dollhouses
Dollhouses--Fiction
Dolls
Dolls-Fiction
Dolphins
Dolphins--Fiction

```
F       Fleischman, Sid.
FLE         Jim Ugly / Illus. by Jos. A. Smith. -- Greenwillow, 1992.
            130p : illus.

            The adventures of 12-year-old Jake and Jim Ugly, his
        father's part-mongrel, part-wolf dog, as they travel
        through the Old West.

            1.  Dogs--Fiction.  2. Mystery and detective stories.  3.
        West (U.S.)--Fiction. I. Title.

                                                                Fic
```

Reprinted with permission from Winnebago Software Company.

TRANSPARENCY 2.4

DOGS

636.7
Col Cole, Joanna.

 My puppy is born / Joanna Cole --
 New York : Morrow Junior Books, c1991.
 unp : col. ill. ; 26 cm

 1. Dogs I. Title

DOGS--FICTION

E
R Rylant, Cynthia.
 Henry and Mudge and the bedtime thumps :
 the ninth book of their adventures / story by
 Cynthia Rylant ; pictures by Sucie Stevenson. --
 New York : Bradbury Press, c1991.
 40 p. : col. ill.

 Summary: Henry worries about what will happen
 to his big dog Mudge during their visit to his
 grandmother's house in the country.
 1. Dogs--Fiction 2. Grandmothers--
 Fiction I. Stevenson, Sucie, ill.

DOGS--STORIES

F Corbett, Scott
COR The disappearing dog trick; illus by
 Paul Galdone. Little, Brown [c1963]
 108p illus

 Kerby Maxwell searches for his dog Waldo

 1 Dogs--Stories I Illus II T

BLACKS--BIOGRAPHY

B
Bet McKissack, Pat.
 Mary McLeod Bethune : a great American educator /
 by Patricia C. McKissack. -- Chicago : Childrens Press,
 c1985.
 111 p. : ports.

 Summary: Recounts the life of the black educator, from
 her childhood in South Carolina to her success as teacher,
 crusader, and presidential advisor.
 1. Bethune, Mary McLeod, 1875-1955 2. Teachers
 3. Blacks--Biography I. Title

BLACKS--BIOGRAPHY

B
Car Mitchell, Barbara.
 A pocketful of goobers : a story about George
 Washington Carver / by Barbara Mitchell ; illustrations
 by Peter E. Hanson. -- Minneapolis : Carolrhoda, c1986.
 64 p. : ill. -- (A Carolrhoda creative
 minds book)

 Summary: Relates the scientific efforts of
 George Washington Carver.

 1. Carver, George Washington, 1864?-1943
 2. Agriculture--Biography 3. Blacks--Biography
 4. Peanuts I.

NEGROES--BIOGRAPHY

B Epstein, Sam
TUBMAN Harriet Tubman, guide to freedom, by Sam and
 Beryl Epstein; illus by Paul Frame. Garrard [c1968]
 96p illus (part col) (Americans all)

 The life of an American Negro woman who helped
 Southern slaves escape through the
 Underground Railroad

 1 Tubman, Harriet (Ross)
 2 Negores--Biography 3 Slavery in the U.S.
 4 Underground railroad

```
                                        DIALPAC
                                DIAL PAC (12 , ttyd1p1)

Call Number        B HEN

     AUTHOR    Dolan, Sean.

      TITLE    Matthew Henson /

  PUBLISHER    [New York] : Chelsea Juniors, c1992.

      DESC.    80 p. : ill. ; 23 cm.

      NAMES    1) Henson, Matthew Alexander, 1866-1955

     TOPICS    1) Afro-American explorers -- Biography
               2) Explorers -- Juvenile Literature.
               3) Afro-Americans -- Biography.
```

Reprinted with permission of Ameritech Library Services

```
        POETRY

            see also

                AMERICAN POETRY
                ENGLISH POETRY - COLLECTIONS
                CHILDREN'S POETRY
```

```
            POETRY--COLLECTIONS

811
Liv     Cat poems / selected by Myra Cohn Livingston ;
            illustrated by Trina Schart Hyman. --
            New York : Holiday House, c1987.
                32 p. : ill.

            Summary: A collection of poems about
        cats by a variety of poets.

            1. Cats--Poetry 2. Poetry--Collections
        I. Livingston, Myra Cohn, ed. II. Hyman,
        Trina Schart, ill.
```

TRANSPARENCY 2.8

AMERICAN POETRY

811
Gre Greenfield, Eloise.
 Night on Neighborhood Street / by Eloise Greenfield ;
 pictures by Jan Spivey Gilchrist. -- New York : Dial
 Books for Young Readers, c1991.
 unp. : col. ill.

 Summary: A collection of poems exploring the sounds,
 sights, and emotions enlivening a black neighborhood
 during the course of one evening.
 1. Blacks--Poetry 2. Community life--Poetry 3. Cities
 and towns--Poetry 4. American poetry I. Gilchrist, Jan
 Spivey, ill. II. Title

AMERICAN POETRY--COLLECTED WORKS

811
Hop Side by side : poems to read together / collected by Lee
 Bennett Hopkins ; illustrated by Hilary Knight. --
 New York : Simon and Schuster Books for Young
 Readers, c1988.
 73 p. : col. ill.

 Summary: A collection of poems especially chosen
 to be read aloud, by authors ranging from Lewis
 Carroll and Robert Louis Stevenson to Gwendolyn
 Brooks and David McCord.

 1. American poetry--Collected works 2. English
 poetry--Collected works I. Hopkins, Lee Bennett, ed.
 II. Knight, Hilary. ill.

```
FIC
Wil     Wilder, Laura Ingalls.
             Little house in the big woods / by Laura Ingalls
        Wilder ; illustrated by Garth Williams. -- Newly
        illustrated, uniform edition. -- New York : Harper & Row,
        c1953.
             237 p. : ill.

             Summary: Laura and her family experience joy and
        hardship in a log house far from any other settlers.

             1. Frontier and pioneer life--Fiction
             2. Wisconsin--Fiction I. Title
```

```
            Little house in the big woods

FIC
Wil     Wilder, Laura Ingalls.
             Little house in the big woods / by Laura Ingalls
        Wilder ; illustrated by Garth Williams. -- Newly
        illustrated, uniform edition. -- New York : Harper & Row,
        c1953.
                 237 p. : ill.

        1. Frontier and pioneer life--Fiction
        2. Wisconsin--Fiction I. Title
```

```
            FRONTIER AND PIONEER LIFE--FICTION

FIC     Wilder, Laura Ingalls.
Wil          Little house in the big woods. Illus. by Garth
        Williams. Newly illustrated uniform ed.
        Harper 1953,c1932
                 237 p. : illus.

        A year in the life of two young girls growing up on the
        Wisconsin frontier.

        1. Frontier and pioneer life--Fiction
        2. Wisconsin--Fiction I. Title
```

```
                    FRONTIER AND PIONEER LIFE--FICTION
FIC
Con      Conrad, Pam.
            My Daniel / Pam Conrad. -- New York : Harper & Row,
         c1989.
            137 p.

            Summary: Ellie and Stevie learn about a family legacy
         when their grandmother tells them stories of her
         brother's historical quest for dinosaur bones on their
         Nebraska farm.

            1. Brothers and sisters--Fiction 2. Nebraska--Fiction
         3. Dinosaurs--Fiction 4. Frontier and pioneer life--
         Fiction I. Title
```

```
745.594    Hautzig, Esther.
HAU            Make it special / cards, decorations, and
           party favors for holidays and other special
           occasions. Illus. by Martha Weston. --
           Macmillan, 1986.
               96 p : illus.

               Provides suggestions and instructions for
           making cards and other things for holidays and
           family celebrations.

               1. Holiday decorations. 2. Handicraft.
           3. Gifts. I. Title.
```

Reprinted with permission from Winnebago Software Company.

Tips for Thinking of Terms

1. **Follow up cross-references.**

2. **Look at the catalog tracings.**

3. **Check a subject authority such as:**
 - *Sears List of Subject Headings*
 - *Library of Congress Subject Headings*
 - *Headings for Children's Materials*

Science projects and activities

507
Cha Challand, Helen J.
 Science projects and activities / by Helen J.
 Challand, Ph. D. ; illustrations by Linda Hoffman Kimball.
 -- Chicago : Childrens Press, c1985.
 93 p. : col. ill.

 Summary: Gives instructions for science projects and
 experiments involving an ant colony, water purification
 and other topics.
 1. Science--Experiements 2. Experiments
 I. Title

SCIENCE--EXPERIMENTS

507
Ale Alexander, Alison.
 Science magic : Scientific experiments for young
 children / Alison Alexander and Susie Bower ; illustrated
 by Carolyn Scrace. -- New York : Simon and Schuster Books
 for Young Readers, c1986.
 45 p. : col. ill.

 Summary: Illustrated instructions for using easily
 available materials in a variety of simple science
 experiments.
 1. Science--Experiments 2. Experiments I. Bower,
 Susie, jt. auth. II. Scrace, Carolyn, ill.

SCIENCE EXPERIMENTS

 see also

 EXPERIMENTS

EXPERIMENTS

550.87
Bar Barrow, Lloyd H.
 Adventures with rocks and minerals : geology
 experiments for young people / Lloyd H. Barrow. --
 Hillside, New Jersey : Enslow, c1991.
 96 p. : ill.

 Summary: Uses earth science experiments for home or
 school to demonstrate the properties of rocks and
 minerals.
 1. Rocks--Experiments 2. Mineralogy--Experiments
 3. Earth sciences--Experiments 4. Experiments
 I. Title

EXPERIMENTS

507
Gar Gardner, Robert.
 Ideas for science projects / Robert Gardner. -- New
 York : Watts, 1986.
 144 p. : ill. ; bibl. -- (An Experimental science
 series book)

 Summary: Introduces the scientific method through
 instructions for observations and experiments in biology,
 physics, astronomy, botany, psychology, and chemistry.

 1. Science--Experiments 2. Experiments
 I. Title

EXPERIMENTS

621.3
Gut Gutnik, Martin J.
 Simple electrical devices / Martin J. Gutnik. -- New
 York : Watts, 1986.

 66 p. : ill. ; bibl. -- (A First book)

 Summary: Descriptions and experiments introduce and
 explain electrical cells, batteries, and other simple
 electrical devices.

 1. Electric apparatus and appliances 2. Electricity--
 Experiments 3. Experiments I.

TRANSPARENCY 2.15

Tips for Thinking of Terms

1. Notice the form or word order of subject headings and infer a pattern.

2. Check the catalog for a known title and follow up by using the same subject headings to find other titles.

3. Check for Cataloging-in-Publication (CIP) with the book in hand and follow up by using the same subject headings.

BRAINSTORM BOX

"Pilgrims and the First Thanksgiving"

PILGRIMS (NEW ENGLAND COLONISTS)

974.4
Sew Sewall, Marcia.
 The pilgrims of Plimoth / written and illustrated by
 Marcia Sewall. -- New York : Atheneum, 1986.
 48 p. : col. ill.

 Summary: Chronicles, in text and illustrations, the
 day-to-day life of the early Pilgrims in the Plimoth
 Colony.

 1. Pilgrims (New England colonists) 2. Massachusetts
 --Social life and customs--1600-1775, Colonial period
 I. Title

THANKSGIVING DAY

974.4
And Anderson, Joan.
 The first Thanksgiving feast / by Joan Anderson ;
 photographed by George Ancona. -- New York : Clarion/
 Ticknor & Fields, c1984.
 [48] p. : ill.

 Summary: Re-creates the first harvest feast celebrated
 by the Pilgrims in 1621 using Pilgrim and Indian actors
 and 17th-century setting of Plimoth Plantation, in
 Plymouth, Mass.
 1. Massachusetts--History--New Plymouth, 1620-1691
 2. Thanksgiving Day I. Ancona, George, ill. II.

THANKSGIVING DAY

B Kessel, Joyce K.
SQUANTO Squanto and the first Thanksgiving. Pictures by Lisa
 Donze. Carolrhoda [c1983]
 47p illus (Carolrhoda on my own bk)

 Explains how the Pilgrims were able to survive the first
 hard Massachusetts winter through the help of Squanto, an
 English-speaking Patuxet Indian

 1 Squanto 2 Pilgrims (New England colonists)
 3 Thanksgiving Day

THANKSGIVING DAY—STORIES

394.26 **Luckhardt, Mildred Corell comp.**
L Thanksgiving; feast and festival; illus. by Ralph
 McDonald. Abingdon 1966
 352p illus
 "A collection of prose and poetry with
 Thanksgiving theme. Includes a section on Thanksgiving in
 foreign lands and group of stories about modern children,
 including those non-English background."
 —Library Journal

 Bibliography Index

 1. Thanksgiving Day—Stories I. Title

TRANSPARENCY 2.19

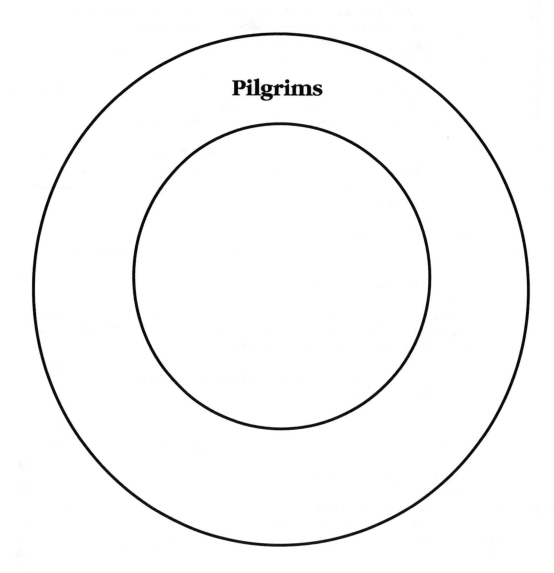

Pilgrims

Graphic Organizers Show the Relationship of Words

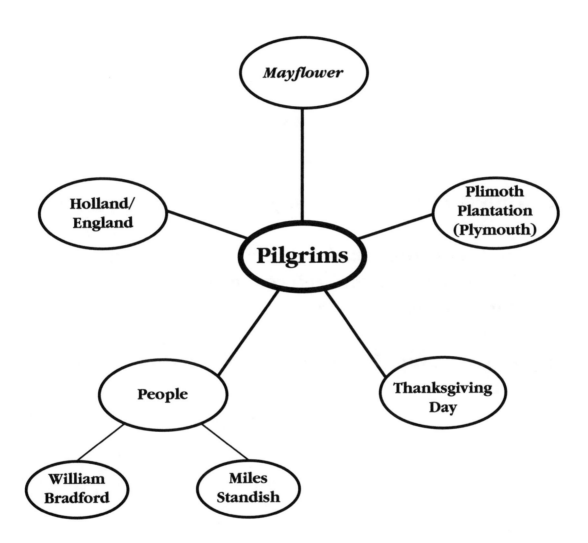

Tips for Thinking of Terms

1. **Think of what you already know about the topic.**

2. **Use the section headings, etc., of your textbook chapter or a general reference article to suggest search terms.**

3. **Design a graphic organizer to group and label terms.**

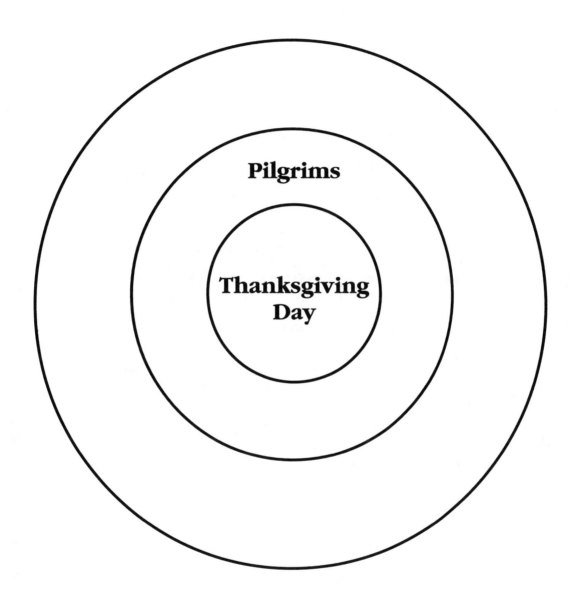

TRANSPARENCY 2.23

MASSACHUSETTS—HISTORY—COLONIAL PERIOD

973.2 **Weisgard, Leonard**
W The Plymouth Thanksgiving; written and illus. by
 Leonard Weisgard. Doubleday 1967
 unp illus
 Traces the story of the Pilgrims from England to
 Holland, then follows them across the Atlantic Ocean
 in the Mayflower and through their harrowing first
 year. The story ends with the Thanksgiving feast the
 Pilgrims shared with their Indian neighbors.

 1. Massachusetts—History—Colonial period 2. Pilgrim
 Fathers I. Title

MASSACHUSETTS--SOCIAL LIFE AND CUSTOMS--1600-1775,
 COLONIAL PERIOD

974.4 Sewall, Marcia.
Sew The pilgrims of Plimoth / written and illustrated by
 Marcia Sewall. -- New York : Atheneum, 1986.
 48 p. : col. ill.

 Summary: Chronicles, in text and illustrations, the
 day-to-day life of the early Pilgrims in the Plimoth
 Colony.

 1. Pilgrims (New England colonists) 2. Massachusetts
 --Social life and customs--1600-1775, Colonial period
 I. Title

U.S.—HISTORY—COLONIAL PERIOD

973.2 **Hanff, Helene**
H Religious freedom; the American story; pictures by Charles Waterhouse; consultant and co-author: Lloyd L. Smith. Grosset 1966
 61p illus map (A Who-when-where book)

 Contents: Colonial America's feudal kingdom; The colony "purchased by love"; The giant mixing bowl; The city of brotherly love.

 Index

OVERLAPPING SUBJECTS

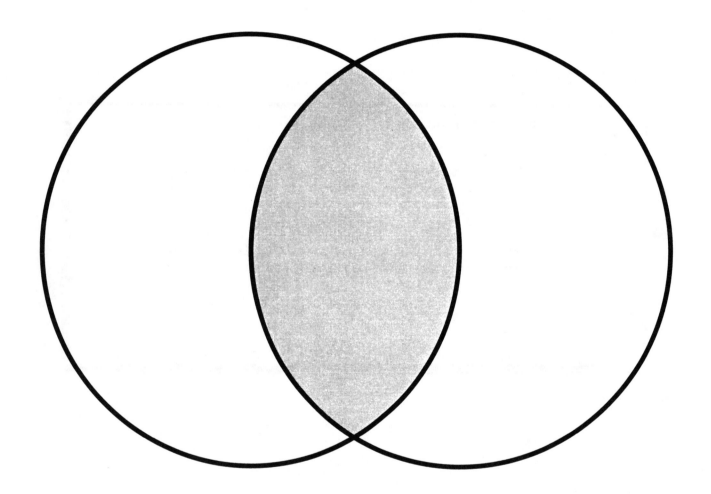

SUBJECT HEADINGS USED IN OUR CATALOG

THANKSGIVING DAY

THANKSGIVING DAY—STORIES

PILGRIMS

PILGRIMS (NEW ENGLAND COLONISTS)

PILGRIM FATHERS

MASSACHUSETTS—SOCIAL LIFE AND CUSTOMS—1600–1775,
 COLONIAL PERIOD

U.S. HISTORY—COLONIAL PERIOD

U.S.—SOCIAL LIFE AND CUSTOMS—COLONIAL PERIOD

COLONIAL AMERICA

COLONIAL LIFE—FICTION

PLYMOUTH, MASS.—HISTORY—FICTION

SQUANTO

HEADINGS NOT USED

NEW WORLD

MAYFLOWER

Student's Name _____ Date _____

Predicting Subject Headings for Science Books

Title of book examined _____

Call number _____

Author's last name _____

Copyright date _____

Predict the subject heading(s) under which this book might be listed in the library catalog.

List the actual subject heading(s) you found for this book in the library catalog.

Student's Name _____ Date _____

FINDING OUT ABOUT THE PILGRIMS
AN INFORMATION PROBLEM-SOLVING ACTIVITY
PART I
A. ORGANIZATION OF THE BOOK

Directions: Record this information about the book that you are examining.

Title _____

Author's last name _____

Call number _____

Is there a table of contents? _____

Is there an index? _____

B. CONTENT OF THE BOOK

1. Examine the reading level. Check one of the following:

 ☐ Written for a younger student?

 ☐ Just right for someone my age?

 ☐ Hard to understand?

2. Examine the book carefully to see if it includes specific information about these things:

 a. Does it discuss why the Pilgrims left England to go to Holland then to America?

 b. Does it describe the *Mayflower* and the voyage to America? _____

 c. Does it describe life at Plimoth (Plymouth) Plantation? _____

 d. Does it describe the first "Thanksgiving"? _____

 e. Does it include the names of some famous Pilgrims? _____

3. Give your opinion of the book. Check all that apply

 ☐ It's a good fact book ☐ It could be helpful for a report

 ☐ It's a good book just to read ☐ It's not useful for any of these

PART II

Directions: Check the following subject headings that might have been used in the library catalog for this book. Look to see if you were correct. Underline the headings actually used.

THANKSGIVING DAY ☐ PILGRIMS (NEW ENGLAND COLONISTS) ☐

MASSACHUSETTS—SOCIAL LIFE AND CUSTOMS—1600-1775, COLONIAL PERIOD ☐

U.S.—HISTORY—COLONIAL PERIOD ☐ OTHER ☐

WORKSHEET 2B

Student's Name _____ Date _____

HOW DO THESE WORDS RELATE?
Graphic Representation of Search Terms

1. Directions: Reorder the words listed and write them in the circles. Write the most specific word in the inner circle. Write the most general word in the outer circle.

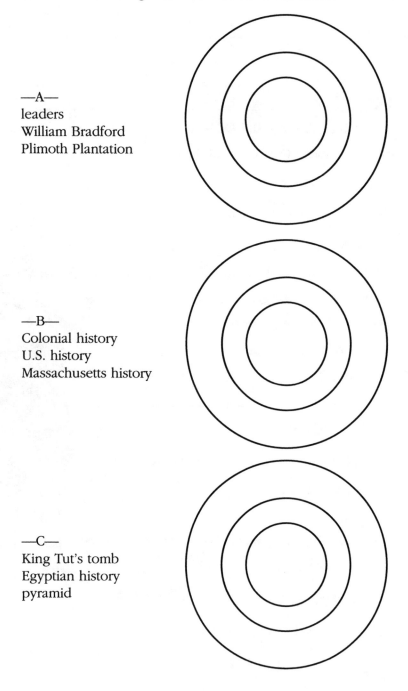

—A—
leaders
William Bradford
Plimoth Plantation

—B—
Colonial history
U.S. history
Massachusetts history

—C—
King Tut's tomb
Egyptian history
pyramid

WORKSHEET 2C

Student's Name _____ Date _____

2. Directions: Label the drawings to represent overlapping subjects. Write the overlapping topic in the gray circle.

—A—
Pilgrims
Colonial America
religious freedom

—B—
Pilgrims
famous ships
Mayflower

—C—
Eskimos
igloos
houses

WORKSHEET 2C (CONT'D.)

Student's Name _____ Date _____

— Answer Sheet —

HOW DO THESE WORDS RELATE?
Graphic Representation of Search Terms

1. Directions: Reorder the words listed and write them in the circles. Write the most specific word in the inner circle. Write the most general word in the outer circle.

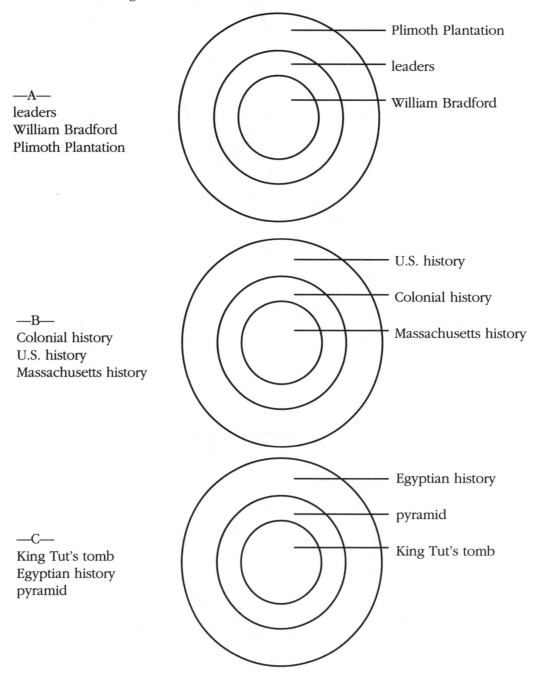

—A—
leaders
William Bradford
Plimoth Plantation

Plimoth Plantation
leaders
William Bradford

—B—
Colonial history
U.S. history
Massachusetts history

U.S. history
Colonial history
Massachusetts history

—C—
King Tut's tomb
Egyptian history
pyramid

Egyptian history
pyramid
King Tut's tomb

WORKSHEET 2C, ANSWERS

Student's Name _____ Date _____

— Answer Sheet —

2. Directions: Label the drawings to represent overlapping subjects. Write the overlapping topic in the gray circle. (A different answer may be equally correct.)

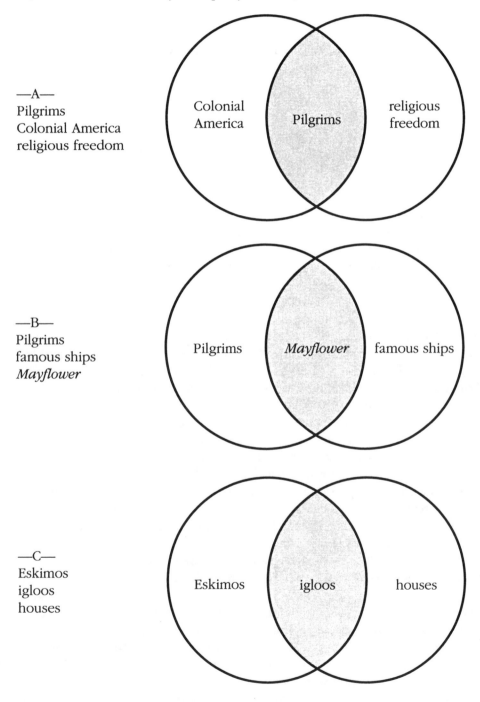

—A—
Pilgrims
Colonial America
religious freedom

—B—
Pilgrims
famous ships
Mayflower

—C—
Eskimos
igloos
houses

WORKSHEET 2C, ANSWERS (CONT'D.)

Chapter 3

Finding an Information Trail Through Indexes

INTRODUCTION

As students are exposed to the concepts covered in the first two chapters, they will see the relationship of their thought processes to their success in identifying indexing terms. To this point, emphasis in the lessons has been on use of the library catalog. The goal, however, is for students to internalize the process and transfer its use to any index.

Although this chapter concentrates on searching in a variety of reference books—including the yellow pages—it differs from the more commonly found "source approach" to library skills instruction. I believe that students benefit from systematic exposure to basic reference sources so that their comfort level with a particular publication will increase as they understand its scope and organization and have a chance to practice looking up topics of personal or group interest. The instructional focus, however, must be on access to the information through the thoughtful and skillful use of the source's index.

Although not explicitly mentioned in this chapter, graphic organizers may be useful in clarifying or illustrating the relationship of indexing terms and may help students relate what they are learning to previous activities. The teacher and library media specialist must be sensitive to the readiness of the class; to impose one form of graphic representation over another would not honor individual learning styles or individual stages of development. The purpose is to facilitate thinking, not to frustrate it.

The following lessons assume the predominate word-by-word alphabetizing of indexes [word-by-word: air, air lines, air pilots, aircraft, airplanes]. Students may benefit from exposure to the alternative approach of letter-by-letter alphabetizing, but care should be taken not to create more confusion [letter-by-letter: air, aircraft, air lines, air pilots, airplanes].

A follow-up activity to index study is for students to create indexes for library books that have none—with adult supervision as needed. These could be submitted for peer review, typed, and permanently affixed to the books.

The instructor is encouraged to develop additional lessons and activities that reinforce index use, both for curricular topics and as a challenging end in itself. I have discovered through many years of observation that young people can become excited about the most unexpected library resource if lessons are developed that pique their interest. A word of caution, however: Commercially produced trivia worksheets are often ineffective, as they were not designed for a particular library's resources or with the sophistication level of the actual searchers in mind. It is suggested that before such materials are assigned, they be given a dry run by the teacher or library media specialist to determine their appropriateness.

STUDENT OBJECTIVES

1. The student will understand the purpose and organization of indexes.

2. The student will use cross-references in a variety of indexes.

3. The student will relate *See* and *See also* references to search word strategies.

LESSON 1 (NARRATIVE): IDENTIFYING CROSS-REFERENCES IN ENCYCLOPEDIAS

Lesson Objective

The student will identify two types of cross-references.

Materials Needed

An encyclopedia volume is needed for each student in the class. Examples of cross-references may be randomly identified by the students, or topics may be assigned on student search cards.

[Reproducible student search card]

Student Search Card
Examples of Cross-References in the Encyclopedia

Use *The World Book Eneyclopedia* (1994), vol. _____

1. _____ . *See* _____

2. _____ . *See also* _____

Student Search Card
Examples of Cross-References in the Encyclopedia

Use *The World Book Encyclopedia* (1994), vol. 1 (A)

1. Alternating current. *See* Electric current, etc.

2. Arctic wolf. *See also* Wolf.

The latter is preferable as it gives more structure to the activity and prompts discussion of topics of general interest to the age group. If the latter option is taken, the instructor will need to prepare a corresponding search card for each volume used by a student. See Appendix A for a list of suggested topics taken from *The World Book Encyclopedia* (1994).

Motivating Activity

Think back to the cross-references you have seen in the library catalog and in reference books, such as the index to the encyclopedia. Cross-references give us many new choices for searching out information.

[Show transparency 3.1]

What does this treasure map have in common with library reference materials? [Encourage such answers as (*Clues or directions are given along the way. Following these may lead to finding the treasure.*)]

In this lesson we will find many examples of cross-references and see just how helpful they can be. Remember, when the authors and editors were writing articles and creating indexes, they wanted you to be successful in finding information. So, if you follow the Cross-Reference Trail that they have included, and think aloud as you go, you almost surely will find treasure at the end of your search!

Presentation

[Show transparency 3.2]

Let's examine in detail how this works. If we look in the encyclopedia for an article on skating, we will find the entry word **Skating** followed by a cross-reference. The cross-reference directs us to "*See* **Ice Skating**; **Roller Skating**." Had we looked first for an entry under **Figure Skating**, we would have found the same cross-reference, "*See* **Ice Skating**."

It is important to understand that a *See* reference is telling us to look for a synonym, or related word. **Ice Skating** and **Figure Skating** mean almost the same thing. The encyclopedia chose to use the term **Ice Skating**, but the editors wanted us to locate the article even if we looked up a different term, so they included the cross-reference.

The *See also* reference leads us to other entry words that can be broader terms, narrower terms, or related terms. Turning to the end of the ice skating article, we find the message "*See also* **Hockey**; **Olympic Games**, etc." Notice that **Olympic Games** suggests a broader word search, since figure skating is only one of many categories in the winter Olympics.

Guided Practice

You give it a try in the encyclopedia volume that you have. Find an example of a *See* reference by looking up the first topic written on your search card. [Or by randomly selecting an example.] If what is written on your card had truly been a subject you were investigating, think about the most likely way you would have looked for it. When I call on you, tell us the entry word only, not the cross-reference, and class members will suggest what the *See* reference might be. Then, you can tell us what you actually find there. [Share as time allows.]

Now look in your volume for the second subject written on the card. At the end of the article, you will find a *See also* reference. Be ready to share what you find and tell how the cross-references are related to the entry word. [Share as time allows.]

Check for Student Understanding

Here is a final interesting example. In some reference books, if we look up the word "Oscar," we will find the message "*See* **Academy Awards**." In *The World Book Encyclopedia,* however, we find the message "*See* **Motion Picture (Festivals and Awards)**." How do you explain these two different messages? Are you surprised to learn that all sources do not use the same cross-reference for the same subject? Now, tell me again how the cross-reference will be stated if the suggestion is to look under additional subject entries for more information. (*See also.*)

Closure

Cross-references are included in indexes and encyclopedia articles to offer help in locating information. These can be either *See* references or *See also* references. We must recognize what they are telling us, and then follow their directions.

LESSON 2 (NARRATIVE): FROM INDEX TO ARTICLE AND BACK—FINDING MORE

Lesson Objective

The student will use index entries and cross-references to compare the content of encyclopedia articles.

Motivating Activity

We have looked at the way an encyclopedia helps us by giving cross-references that may follow entry words or be at the end of an article. Whoever wrote and organized these articles and the index wanted us to be successful in finding information. They tried to anticipate the words people would use in looking, and then suggested alternatives when necessary. [At this point, remind students of an interesting example someone found in the last lesson.]

Presentation

Let's do a search together to illustrate just how important it can be to follow up on cross-references. [Show the class an illustration of a sled with sled dogs; avoid showing title or captions.] We will focus on this picture for a moment. Then, in order to allow our minds to make connections, and to consider what we already know about the topic suggested by this picture, we will collect words in a Brainstorm Box.

> [Show transparency 3.3]

> [Suggestions will probably include *Sled Dog, Sledding, Husky, Siberian Husky, Eskimo Dog, Eskimo Transportation*, etc.]

Although you may have been thinking of several places you could look for information, we will start our search with the encyclopedia.

> [Show transparency 3.4]

I have reproduced one of the index pages from *The World Book Encyclopedia*. We will begin by looking in the index for the term **Dog Sled**. In parentheses, we see **Vehicle**, which is given for clarification. Under this main entry, notice there are several subtopics listed in alphabetical order. These serve as *See* references. They indicate that dog sleds are discussed, or at least mentioned, in other articles, but that there is not a separate article on the topic.

> [Show transparency 3.5]

Now, let's compare the index entry for **Dog Sled** with the index entry for **Sled**. Do you see that there is an article about sleds in the *S* on volume, page 505? Notice, too, that several of the same subtopics are

listed under both entries. Which entry under **Sled** might relate to **Dog Sleds** and provide a lead we did not see under that entry? (*Yukon Territory.*)

> [Instructors may wish to make transparencies or photocopies of the below-mentioned encyclopedia articles for use in this lesson so that students can follow the comparison.]

When we turn to the actual article entitled "Sled," we find mentioned two types of construction used in Alaskan and Canadian dog sleds pulled by huskies. There is little information here about the dogs or how they are hitched, etc. The cross-references at the end of the article do not help because they concern other types of sleds, not dog sleds.

Next, we check the article entitled "Sled Dog." Here we find much information about the types of dogs and about sled-dog racing. The article does not mention any of these races by name, however. If we decide to follow up on the cross-reference to **Alaska**, **Visitor's Guide**, **Annual Events**, we will see the Iditarod Trail Sled Dog Race listed in the January–June events (*The World Book Encyclopedia* [1994], vol. 1, p. 291).

Now, we could stop right here and feel pretty good about the information we have found. But, is anyone remembering seeing pictures somewhere of sled-dog teams hitched in a way other than two-by-two? Why don't we just check that other *See also* reference under **Sled** in the index. When we find the transportation section of the "Eskimo" article, there is more information included after all on the types of sleds and on hitching the dogs. There is even an illustration of frame and plank sleds. You can see that it was well worth the time to follow through on the cross-references.

Closure

From the experience we have had today in tracking our trail from index to articles to cross-references and back again, we realize how important it is to follow up on the suggestions given in the cross-references. We might miss good, usable information if we quit our search too soon.

LESSON 3 (NARRATIVE): ALMANACS—THE SUPER INDEX

Lesson Objective

The student will use common search word strategies to locate information in an almanac.

Materials Needed

For this lesson, each student in the class will use a copy of a recent edition of an almanac.

Motivating Activity

You are familiar with using our library catalog to acquire books on topics of interest and with locating encyclopedia articles that offer more concentrated information. In this lesson, you will apply the same search word strategies you have already learned as you look up things in the "super index" of an almanac.

The information you will find in an almanac is very different from that found in a more lengthy book, magazine, and encyclopedia articles. The scope is different. The appearance on the page is different. These differences will soon become apparent if they are not already. You will also find that the index is absolutely essential for locating tables, charts, etc., that contain needed information. And to use the index effectively requires that you think through the question and remain flexible in your search for the answer.

Before we talk about the effective use of this reference book, let's see how well you do independently using what you already know or can figure out. I want you to find out some facts about the famous annual dog-sled race called the Iditarod. [Substitute a topic of current interest to the students, if preferred.] See if you can find out the distance, or mileage, of the race and where it takes place. [Allow a few minutes for searching, depending on the frustration exhibited by the class. Ask a student who has been successful to give the page number, and the class to discuss briefly what has been found.]

Presentation

In the index, you could have looked under either **Dogs—Sled Dog Racing**, or **Racing—Sled Dog** and found the same page reference. It did not work to look under the term "Iditarod." So, in this case an overlapping word search strategy worked and a keyword search did not. Notice that to be successful, you had to use the index! We will be using the almanac index to practice our search word strategies and to make decisions about which terms to try as subject entries.

As a class, let's work through another question to demonstrate how the index allows us to be successful even with different approaches.

Take the question, "Who won the Rose Bowl game in 1963?" This can be approached as a keyword search by looking under the specific event. When you look in the index under *R* for **Rose Bowl**, you will see it listed there along with a page number on which a table of annual winners is given. When you turn to that page, you can find the answer. You could also look in the index for a broader word—**Bowl Games**—and find the same page reference and same table. Or you could go one level higher and consider **Football** as the point of entry to the index. In this case, you would have to know if the Rose Bowl game was a college or professional event. Looking at the subheadings listed under **Football, College**, you will find **Bowl Games** there with the same page noted. So, working from a keyword to an increasingly broader topic, it was possible to find the answer using any of these three approaches to the index: **Rose Bowl, Bowl Games**, and **Football**. Still, you must beware of assumptions. Just because this specific bowl game was indexed separately doesn't mean that all will be. Check the index for a few others,

such as Gator Bowl and Cotton Bowl. [Unlike the Rose Bowl, these are not listed as separate entries by name.] Can you think why there is a difference? (*Perhaps they are less prestigious.*)

Let's explore another question. If I ask you "How cold has it ever gotten in our state?" you would have to think a while about possible indexing terms. **Cold** certainly would not be considered a likely keyword. And the main topic of the question is not the state's name. So, using related terms, or actually rewording the question, we might think of **Weather** or **Temperature** as the real keyword. Either of these would work as index entries. "How cold has it *ever* gotten?" also suggests a "Record Temperature," and this is actually the name of the table that you will need to consult for the answer to the question.

Guided Practice

Here is a question to investigate on your own. Then we will see how many different ways people approached the index. "Which states have a part of their territory in the Great Smoky Mountains National Park?" Keep track of all index entries that you try, and be ready to discuss which of them worked.

Closure

Because of an almanac's arrangement and complexity, it is essential to begin with its index and to analyze your question carefully. Flexibility in moving back and forth among search word strategies will produce greater success in finding information.

LESSON 4 (NARRATIVE): SEARCHING THE YELLOW PAGES

Lesson Objective

The student will use search word strategies to locate information in the yellow pages of the telephone directory.

Materials Needed

Enough copies of the same telephone directory will be needed for individual students or pairs of students in the class.

Motivating Activity

Turning our attention to an information source closer to home, we will have some fun using the yellow pages of our own telephone directory. These yellow pages are an index to businesses and services in our community. As with any good index, we hope cross-references will be included to guide our search. And we will have to apply search word strategies to know where to look. Now, doesn't this sound like a challenge that will have real-life benefits?

Presentation

> [The instructor will need to modify the following explanation
> for use with the specific directory used.]

In using the yellow pages index, what we notice first is the way information is printed on the page. Guide words appear at the top of pages. Subjects and categories are arranged alphabetically as in other indexes, but ovals are drawn around each of these words or phrases. Business names, addresses, and telephone numbers are listed under each subject or category. Sometimes words are not spelled out, so figuring out the abbreviations makes this index a little difficult to use.

We will start with a simple search question and work this through together. "Where can you go in our community to buy baseball cards?" Turn through your yellow pages and look for the heading **Baseball Cards**. [Allow time for students to search, then give the page number before continuing.] Two shops are listed along with a cross-reference, *See also* **Collectibles**. What is the relationship of the term **Collectibles** to **Baseball Cards**? (*"Collectibles" is a broader term that includes baseball cards.*)

Here is something else to note. Right after the entry **Baseball Cards**, we see **Baseball Equipment** with a cross-reference, *See* **Sporting Goods**, a more inclusive, or broader, term. Library reference book indexes likely would not use the term **Sporting Goods**, but the yellow pages often use terms that regularly appear in commercials and advertisements.

Guided Practice

You may realize that an advertisement for a business often appears in the yellow pages at or near the index entry. With this in mind, consider another possible real-life question. "Can you find the name of a toy store that carries Legos™?" Thinking of the level—or hierarchy—of terms, consider **Legos™**, **Toy Store**, then **Stores**. Next, choosing a midlevel entry to the index, look for toy stores under the word **Toy**. [Allow students to get to the page on their own, then continue.] What you find is a section named **Toys** without the word stores, but it is clear that you can now find your answer.

Try another search. Let's say someone has thrown out the newspaper, and you want to know what time the Saturday afternoon movie starts at the shopping mall near the school. Let's see if the yellow pages can provide some help. [Give students time to investigate independently or in pairs.] When we check for the keyword **Movies**, we find no listing and no cross-reference. We might then think of several related terms. **Picture Shows** is a term older adults might try, but that is not listed. **Cinema** might be a word you'd think to try, but it is not listed. **Motion Pictures** is listed, but as "**Motion Picture Theatres**. *See* **Theatres**." If we had looked for the entry **Theaters**, we would not have found it because of the different spelling; but the spelling **Theatres** does give us the telephone number we need in order to call and find our answer.

Check for Student Understanding

How are the yellow pages like the library catalog? (*They are both indexes.*) How are they like a dictionary? (*They are alphabetically arranged.*)

Closure

The yellow pages serve as an index to local businesses and services of our community. They provide an alphabetical subject arrangement with cross-references, but the terminology is often very different from standard library terminology.

LESSON 5 (NARRATIVE): GO TO IT! LOOKING UP PLACES YOU KNOW IN THE YELLOW PAGES

Lesson Objective

The student will use a variety of search word strategies to locate information in the yellow pages of a telephone directory.

Materials Needed

Enough copies of the same telephone directory will be needed for individual students or pairs of students in the class. [Be sure to check the examples against the edition used.]

Motivating Activity

We will continue exploring the yellow pages in order to practice using our search word strategies. In using any index, whether it is the library catalog, an encyclopedia's index, an almanac's index, or the yellow pages, it is a challenge to identify the indexer's word choices. We must keep returning to the basic ideas of keyword, related word, broader word, narrower word, and overlapping subject, and be able to shift from one to another until we are successful. Remember, too, that the terms you find used as index entries in the yellow pages are not necessarily the words you will find used in other reference books or in the library catalog.

Presentation

We have already seen that thinking of related words is frequently necessary. Often there are no cross-references to help you. This is true for **Car Repair**, for which there is not an entry. You must look under **Automobile Repair**. It is true for **Lawyers**—you must look under **Attorneys**. For videocassette rental, look under **Video Tapes & Discs—Renting & Leasing**.

 Together, let's work through another question. Someone give us the name of a local vet. Now let's find out that doctor's weekend hours. We could, of course, just look up the doctor's name in the business white pages, then call the number listed and ask about the hours, but how can we find out the phone number using the yellow pages? Is this another case where we will need to use a synonym or related term? Yes, we'll need to look under **Veterinarians**, not the abbreviation, **Vets**. Some of you may be wondering "How in the world do you spell that word?" If you can spell the first two syllables, you will probably get close enough in the listing to spot it. [Give students time to locate the information; discuss.]

 Here is a question that requires real flexibility in thinking because we will find what seem to be inconsistencies in the index. Can you find our school listed with its street address? First, we select a broader word, **School**, not the school's name. Under that entry—**School**—we soon realize that we might have to select a narrower term: **Public School**. We see a subheading, **Schools—Private**, but we do not see a corresponding one for **Schools—Public**. What we find instead is **Schools—Secondary & Elementary**. So we look there. Under that subheading, we move to an even narrower term still by looking under the school district's name, where we find one alphabetical list of schools. Our school is listed with its street address. Finally! Sometimes when the indexing is particularly difficult, as in this example, people obviously complain to the compilers of the yellow pages, because the heading are sometimes changed or simplified from one edition to the next.

Guided Practice

Now do some searching on your own. Think of some businesses you and your family patronize, places you go to shop. Here are some suggestions: places you buy food, places you buy clothes, places you borrow books, places you rent video tapes. On a piece of paper, write down the name of the place you want to look for along with the search word strategy you think will work. Then, keep count of how many tries it takes you to find the indexing term under which that business or service is actually listed in the yellow pages. We will work on this activity a few minutes independently, then see how well we do with looking up some of each other's suggestions. [Continue as time allows.]

Check for Student Understanding

Let's do two final searches together. In looking in the yellow pages for a list of orthopedic surgeons, what search word strategies are involved? (*Broader word, "doctors"; related word, "physicians."*)

What would you do with this statement: "I feel like Chinese food tonight." First determine if what the person wants is to be taken out to dinner, not just told where to buy oriental ingredients for cooking it at home! Then, by thinking of a broader topic—**Restaurants**—locate subheadings indicating nationality, and you will find a list of Chinese restaurants. Now that should do it! Enjoy!

Closure

Using the yellow pages can be quite a challenge, as you can see. Would the following be the advice that you would give to someone just beginning to use the yellow pages? "In any search for information, first think through the question. Decide the most likely words to use in your search, but be patient until you find the terms the indexer used. Look for clues as you go and keep thinking!"

LESSON 6 (NARRATIVE): GETTING INTO MAGAZINES

Lesson Objective

The student will recognize the purpose and general format of magazine indexes and will relate search word strategies to the finding of potentially useful articles.

Materials Needed

Provide enough issues of magazines to which the library media center subscribes so that each student can have one to examine.

Provide each student with an issue of *Children's Magazine Guide* (Reed Reference Publishing, 121 Chanlon Road, New Providence, New Jersey 07974-1154). Include both bimonthly and cumulative issues in magazines distributed.

Motivating Activity

You will find placed before you several back issues of some of our popular magazines including *3-2-1 Contact*, *Dolphin Log*, *Sports Illustrated for Kids*, *National Geographic World*, *Odyssey*, and *Cobblestone*. Now, if I asked you to find some articles on basketball greats, it is obvious which magazine you would reach for first. If I asked you to find science articles, it's not so obvious. Let's do an exercise to get us thinking about getting into magazines and finding information. Choose one of the magazines and browse through it a moment looking for articles that pique your interest. I will make a list of a few interesting-sounding titles that you suggest. [Ask for suggestions from students. Record these on a transparency or on the chalkboard.]

Presentation

Notice that our list includes articles on several topics. [Categorize the titles on the list by their topic.] You were asked to cite articles that caught your eye as you turned through. What if I had been more specific and asked you to locate an article on spiders or pumpkins or volcanoes! Of course not all these topics will have had articles written about them in the magazines we looked at, but it's likely they have had at one time or other. It's just a question of where to begin looking in all the back issues. We might predict that pumpkins would be in an October or Halloween issue of some magazine. If there had been a volcanic eruption somewhere in the world lately, we would expect one of the science and nature magazines to have written about it. You can see, however, that randomly skimming through back issues of magazines is not an efficient way to search.

Some of you know where we are going with this line of thought. "How about an index to magazines, like our library catalog is an index to books and materials, like the encyclopedia has an index to its articles, like the yellow pages is an index?" you may be thinking. Exactly. That is what we need. We need an index that will list magazine articles by subject and will indicate the specific magazine issues in which these articles appeared.

For many years, a standard print index has been *The Readers' Guide to Periodical Literature* (H. W. Wilson Company, 950 University Avenue, Bronx, New York 10452). You may have seen this index at the public library or heard older brothers and sisters talking about it. In addition, there are online indexes to magazines and all sorts of other specialized indexes.

We are going to use *Children's Magazine Guide*, however, which is just right for your age since it indexes most of the magazines you enjoy including those to which we subscribe. [Point out the indexed magazines and their abbreviations as listed on the inside cover of each issue of the *Guide*.]

[Show transparency 3.6]

Together we will examine a cumulative issue that indexes articles appearing from September 1993, through August 1994. A cumulative issue combines several monthly issues. We will notice how subject entries look and how cross-references are indicated. As we do this, keep in mind the other indexes we have studied and notice similarities and differences.

Let's say we want to find up-to-date information on endangered sea mammals. We may decide first that, in order to be as current as possible, we will look only for magazine articles published after the summer of 1993. So we turn to *S* in the index and look for an entry on sea mammals. On page 103 we find **Sea Lions** but not **Sea Mammals.** We notice, however, a cross-reference, **Sea Animals:** *see* **Marine Animals.** Looking under **Marine Animals** gives us quite a few entries, but none of the titles sounds likely for our particular focus.

It's time to reconsider the question rather than to give up. Maybe the actual topic is endangered animals, and sea mammals is just a category under endangered animals. With this in mind we turn to *E* and look for **Endangered Animals**. Notice the entry on page 43 is actually **Endangered Species.**

[Show transparency 3.7]

Again, we glance down the list of articles indexed, and none of the titles specifically mentions sea mammals. We still might want to retrieve a few of these issues and skim the articles to be sure, but our best lead seems to be the cross-reference that reminds us to look also under the names of endangered species. In order to follow this suggestion, we would need some prior knowledge of animal names that might apply.

[Show transparency 3.8]

Checking first under **Whales**, we find a reference to the return of the gray whale in the January 1994 issue of *Dolphin Log*.

[Show transparency 3.9]

Looking under **Manatees** on page 74, we find three articles listed.

[Show transparency 3.10]

When we check the entry **Dolphins**, we see quite a few articles, but judging from their titles and numbers of pages, we might surmise that the *National Wildlife* article, "Thinking About Dolphins," is our best bet.

Let's leave that topic of endangered sea mammals for a moment. What if we were looking for information on a current events topic or something that had just recently been in the news—say, the opening of the tunnel under the English Channel that connects England and France. It is called the "Chunnel." Although that may seem too specific a term for an index entry, it is listed that way, so we were wise to begin with the actual topic we wanted rather than to move too quickly to a broader or related topic.

[Show transparency 3.11]

We would not expect to find this entry in every issue of *Children's Magazine Guide,* but it is a topic of current interest and has been written about in several different magazines.

Do you see how this could suggest a strategy for finding information on other topics? If you wanted information on the *Exxon Valdez* oil spill, first use a different source to find out the date of the disaster, then look back in index issues following that time and you would expect to locate many articles on the topic.

Guided Practice

Here is a back issue of *Children's Magazine Guide* for each of you. For a few minutes, I want you to practice looking up different subjects and noting what entry words and what cross-references you find. Remember, each of you is using a different month's index, so what you find will differ. First, see if your issue includes any articles on constellations, air pollution, Christopher Columbus, Pilgrims, or electronic games, then you can spend some time browsing in the index on your own. [Share as time allows.]

Closure

Some of you found no articles on Christopher Columbus. Had you been using issues for 1992, however, you would have found many references. Why might that have been? (*That was the 500-year anniversary of Columbus's voyage.*) And how about Pilgrims as a topic? Did anyone remember the overlapping subject strategy linking U.S. history and the colonial period? When you looked for an entry on electronic games did you come up empty-handed? Thinking of either **Computer Games** or **Video Games** as related topics gave good results and may even have led you to **Virtual Reality** as an entry. What seems more apparent than ever is that indexes offer the thinking person greater success. That is because the thinking person analyzes questions and moves back and forth between the various search word strategies.

LESSON 7 (NARRATIVE): POETRY FROM SEVERAL DIRECTIONS

Lesson Objective

The student will use a variety of indexes that are included in poetry anthologies.

Materials Needed

Each pair of students will share a poetry anthology. Older volumes as well as recently published titles should be represented. Two anthologies, *The Random House Book of Poetry for Children* (selected and introduced by Jack Prelutsky; Random House, 1983) and *Sing a Song of Popcorn: Every Child's Book of Poems* (selected by Beatrice Schenk de Regniers, Eva Moore, Mary Michaels White, and Jan Carr; Scholastic, 1988) are specifically used in the presentation.

Motivating Activity

If I asked for a copy of the famous narrative poem "'The Night Before Christmas," do you know where you would look? Some of you might remember seeing a little paperback copy with lavish illustrations and would head for the library catalog to find how it's listed and where it is shelved. But just to complicate the search, I have deliberately given you the poem's popular title rather than its real title. If you are lucky, however, you may use that as a lead in the library catalog and determine who the poet was. Because we want to continue developing our skills with indexes, however, we are going to find the poem in one of our anthologies. A good anthology to begin with is *The Random House Book of Poetry for Children,* since it includes the four basic types of poetry indexes: index of titles, index of authors, index of first lines, and index of subjects. Instead of doing the actual search for the Christmas poem right now, we will let two of you find it later in the period while everyone else is practicing with the indexes.

Presentation

Let's work through a different search together. Here's an even more difficult question. Using this same anthology, how can I find the poem that talks about being "kissed by the rain" and the rain's "singing a lullaby"? That's not much to go on, is it? We have the keyword, **Rain**, and a broader word, **Weather**, but we don't know the author, the title, or the first line of the poem. We check the subject index. There is no entry under **Weather**. Then, looking under **Rain**, we see eight pages listed. After checking the poems on each page, we locate Langston Hughes's lovely poem "April Rain Song," and so our search was a success! [Read the poem aloud.]

What if, instead, you had begun your search with another poetry anthology, *Sing a Song of Popcorn: Every Child's Book of Poems*? You would turn to the back and find an index of titles, an index of first lines, and an index of authors, but no subject index. Often, poems are grouped by topic in anthologies, so maybe the table of contents can give you direction, you think. Turning there, we find a section called "Mostly Weather." Skimming through the titles listed, we see several that could be possibilities, but we would probably try the ones with **Rain** in the title first. By doing this, we soon come upon "April Rain Song" and realize it is the one we were looking for.

Guided Practice

For a while, you will work with partners and examine poetry anthologies to see if you can find certain poets and titles I will suggest. We will share a few of your favorite poems as time allows. [Because of the great variation in poetry collections, I have included no specific list of poem titles. In creating task cards

for the students, select topics of interest or poets and titles with which they may be familiar. Include Robert Frost, Gwendolyn Brooks, Eve Merriam, David McCord, Myra Cohn Livingston. Be sure to assign "'Twas the Night Before Christmas" to a pair. Hopefully, they will find its actual title, "A Visit from St. Nicholas."]

Closure

We have seen the wide variation in formats of poetry anthologies in our media center, and now we have a better idea of how to use anthologies to advantage. In those cases where subject indexes were included, it was interesting to note the use of cross-references. No matter what the route we take, no matter from which direction we enter, browsing through the poetry shelves can provide us with a very pleasurable experience.

WHAT DO THESE HAVE IN COMMON?

1.

2. **SASQUATCH.** **See BIGFOOT**

 SAND DUNE. **See DUNE**

 SHIPWRECK. **See also SALVAGE; SHIP (Safety at Sea); *TITANIC***

 SHOULDER. **See also COLLARBONE; JOINT; HUMAN BODY (picture)**

TRANSPARENCY 3.1

CROSS-REFERENCES

SKATING. See Ice Skating; Roller Skating.

FIGURE SKATING. See Ice Skating.

**FINGERPRINTING. See also Crime Laboratory;
DNA Fingerprinting;
Footprinting.**

(Excerpted from *The World Book Encyclopedia* © 1994 World Book, Inc., 525 W. Monroe, Chicago, IL 60661. By permission of the publisher.)

TRANSPARENCY 3.2

BRAINSTORM BOX

"Dog Sled"

TRANSPARENCY 3.3

INDEX ENTRIES

Dog racing (sport) D:283 with picture
 Sled dog S:505
Dog-rose (plant)
 Brier B:618
Dog salmon See Chum salmon in this index
Dog show
 Dog (Dog competitions) D:280
Dog sled (vehicle)
 Alaska (Visitor's guide) A:290 with picture
 Eskimo (Transportation) E: 363 with pictures
 Sled S:505
 Sled dog S:505
Dog Star See Sirius in this index
Dog tag (military)
 Civil War (The enlisted men) Ci:620

(Excerpted from *The World Book Encyclopedia* © 1994 World Book, Inc., 525 W. Monroe, Chicago, IL 60661. By permission of the publisher.)

COMPARISON OF INDEX ENTRIES

Dog racing (sport) D:283 with picture
> **Sled dog S:505**

Dog-rose (plant)
> **Brier B:618**

Dog salmon See Chum salmon in this index

Dog show
> **Dog (Dog competitions) D:280**

Dog sled (vehicle)
> **Alaska (Visitor's guide) A:290 with picture**
> **Eskimo (Transportation) E: 363 with pictures**
> **Sled S:505**
> **Sled dog S:505**

Dog Star See Sirius in this index

Dog tag (military)
> **Civil War (The enlisted men) Ci:620**

SLBMDS
Radar (in the military) R:65

Sled S:505
> **Bobsledding B:445**
> **Eskimo (Transportation) E:363 with pictures**
> **Luge L:519**
> **Safety (in Winter Sports) S:12 with picture**
> **Sled dog S:505**
> **Snowmobile S:541 with picture**
> **Tobogganing T:308**
> **Transportation (Prehistoric times) T:385**
> **Yukon Territory picture on Y:588**

Sled (equipment)
> **Mine warfare picture on M:565**

Sled dog S:505 with picture

Sledge (transportation)
> **Invention (Prehistoric times) I:358**
> **Sled S:505**
> **Transportation (Prehistoric times) T:385 picture on T:386**

CHILDREN'S MAGAZINE GUIDE®

Subject Index to Children's Magazines

Indexing
magazines published during
SEPTEMBER 1993
through
AUGUST 1994

This is a cumulative issue.

Volume 46 • Number 10

R.R. BOWKER®
A Reed Reference Publishing Company

TRANSPARENCY 3.6

(Reprinted with permission of R.R. Bowker, A Reed Reference Publishing Company from *Children's Magazine Guide,* volume 46, Number 10, © 1994, by Reed Elsevier, Inc.)

43

ELEPHANTS - FICTION (cont.)
The Young Elephant. A.Devendorf.
Ladybug Nov '93 p8–12
ELEPHANTS - POETRY
The Elephant Carries a Great Big
Trunk. Ladybug Nov '93 p7
An Elephant Is Hard to Hide.
J.Prelutsky. Ranger Rick Dec '93
p14–15
Holding Hands. L.M.Link. Sesame
Apr '94 p2–3
ELEVATORS
Big Picture. (How an elevator works)
Contact Mar '94 p32
ELLERBEE, LINDA
Linda Ellerbee. Bio Today Apr '94
p48–55
EMANCIPATION PROCLAMATION
The "Great Emancipator." H.Holzer.
Cobble May '94 p24
EMOTIONS: see also Fears and Phobias;
Laughter; Self-confidence
Don't Let the Grouches Get You!
J.Peck. Humpty D Jun '94 p32–33
EMPLOYMENT: see also Disabled Per-
sons - Employment; Student Jobs;
Summer Jobs
ENDANGERED SPECIES: see also
Wildlife Conservation; also names of
endangered species, as Cranes; Oce-
lots; Orangutan; Rhinoceros
America's Aching Mussels. (Freshwater
mussels - among the nation's most
endangered animals) F.Kuznik
Nat Wildlife Oct-Nov '93 p34–39
The Case of the Disappearing Quail.
B.Lawren. Nat Wildlife Oct-Nov '93
p40–43
Little Birds Lost. (Hawaii's rare honey-
creepers) M.Rogers. Nat Wildlife
Oct-Nov '93 p20–27
One Chance Is All We've Got: Save
Endangered Species Now! (Poster)
SuperSci Blue May '94 supp
Rescue from the Twilight Zone. R.Di
Silvestro. Int Wildlife Jan-Feb '94
p4–13
Saving Endangered Species: A New
Approach. H.Westrup. Cur Sci
Sep 3 '93 p4–5
Should We Put Them All Back? Rein-
troducing Endangered Animals Is a
Much-Ballyhooed Strategy for Sav-
ing Species. F.Sunquist. Int Wildlife
Sep-Oct '93 p34–40
ENDANGERED SPECIES - FICTION
Adventures of Ranger Rick: A Big Cat
Makes a Comeback - Right into
Trouble! R.L.Donald. Ranger Rick
Sep '93 p12–15
ENDANGERED SPECIES - POETRY
Endangered. P.J.Wheeler. Odyssey
Jun '94 p16

ENERGY CONSERVATION: see also
Recycling
Save Your Energy. SuperSci Blue
Oct '93 p7
ENERGY RESOURCES: see also Ocean
Energy Resources; Solar Energy;
Wind Power
Deep Heat. (Geothermal energy)
D.J.Fishman. Sci World Nov 5 '93
p14–19
Underwater Windmills. Cur Sci
Dec 10 '93 p14
ENGINEERING: see also Architecture
Scout Program: Engineering - Making
It Big. W.E.Butterworth UV.
Boys' Life Sep '93 p44–45
ENGINES
World's Tiniest Engine Fits in a Dot.
Cur Sci Feb 11 '94 p10
ENGLAND: see also Castles - England
England's Lake District: Beauty Be-
sieged. B.Bryson. Nat Geog
Aug '94 p2–31
ENGLISH LANGUAGE: see also Word
Origins
Doggy Definitions. Chickadee
Summer '94 p24–25
Fun with Words. Calliope Jan-Feb '94
p32–33
Will I Be a Patient Patient? J.Barnhart.
Playmate Dec '93 p20–22
ENVIRONMENT
Earth Wise: Sing a Biome Song.
Child D Oct-Nov '93 p26–27
ENVIRONMENTAL CONCERNS: see
also Everglades National Park (Fla.)
Adventures of Ranger Rick: Rick and
the gang Visit Costa Rica - And Go
Bananas. L.Prescott. Ranger Rick
Feb '94 p14–17
Are We As Rich As We Think? (Natu-
ral-resource accounting) S.Siwolop.
Int Wildlife May-Jun '94 p12–15
Can the Military Clean Up Its Act?
M.Tennesen. Nat Wildlife
Oct-Nov '93 p14–19
Carving Up Tomorrow's Planet. (Inter-
view with conservation strategist
John G. Robinson) Int Wildlife
Jan-Feb '94 p30–37
Charting a New Course. F.Kuznik.
Nat Wildlife Aug-Sep '93 p36–37
Creating a Greener, Cleaner Planet
Starts at Home. Cur Health Oct '93
p6–11
Current Events: A World at Risk.
(Poster) Cur Ev Jan 24–28 '94 supp
Dioxin's Toll on Wildlife. V.Monks.
Nat Wildlife Aug-Sep '94 p8–9
Earth Wise: Happy Earth Day!
B.J.Letchworth. Child D
Apr-May '94 p20–22
Ecotourism: Gentle Journeys. J.Dunn.
World Apr '94 p25–27

TRANSPARENCY 3.7

(Reprinted with permission of R.R. Bowker, A Reed Reference Publishing Company from *Children's Magazine Guide,* volume 46, Number 10, © 1994, by Reed Elsevier, Inc.)

123

WATER SKIING (cont.)
Real Kids: Fantastic Feet! L. Cameron.
U*S*Kids Jul-Aug '94 p2–5
WATER SPORTS: see also Water Skiing
WATER SUPPLY: see also Water Pollu-
tion
Tapped Out! We're Running Out
of Water. R.Hacker. Contact
Jun '94 p16–19
A World of Thirst. J.Plaut. Sci World
Dec 3 '93 p10–13+
WATERFALLS: see also Niagara Falls
(N.Y. and Ont.)
WATERMELONS
All about Watermelons. Sciland
May '93 fc-26
WATERSON, BILL
A Boy and His Tiger: Calvin and
Hobbes. H.Higdon. Boys' Life
Sep '93 p46–47
WAVES
Surf's Up! SuperSci Red May '94 p4–5
Weather: Predicting Pounding Waves.
N.Sankaran. SuperSci Blue Feb '94
p5
WEATHER: see also Climate; Fog; Hurri-
canes; Lightning; Rain; Snow; Winds
Record Flood Ends Soggy Year.
Cur Sci Mar 25 '94 p15
Weathering the Summer of 1993.
C.Freiman & N.Karkowsky.
Sci world Oct 22 '93 p10–13
Weird Summer Weather Shatters Re-
cords. Cur Sci Oct 15 '93 p14–15
WEATHER FORECASTING
Be a Weather Detective! SuperSci Red
Oct '93 p4–5
WEDDINGS - FICTION
A Dress for the Occasion. C.Stier.
Child Life Jan-Feb '94 p16–19
WEIGHT CONTROL: see also Body Im-
age
To Eat or Not to Eat: The Dieter's Di-
lemma. M.Kusinitz. Sci World
Jan 14 '94 p18–22
WEIGHT CONTROL - FICTION
Who Is That Skinny lady? S.Cleaver.
Playmate Mar '94 p40–44
WEIGHT LIFTING
How to Make a Muscle. J.Csatari.
Boys' Life Apr '94 p64
WEISS, SHAUN
Celebrity Sportalk: Shaun Weiss the
Mightiest Duck. W.Etheredge.
KidSports Mar-Apr '94 p9
WEREWOLVES - FICTION
What Big Teeth You Have.
T.Bateman. Child Life Oct-Nov '93
p4–7
WEST AFRICA: see Africa - West
WEST (U.S.): see also Frontier and Pio-
neer Life; Powell, John Wesley

WEST (U.S.) (cont.)
Federal Lands: New Showdowns in the
Old West. R.Conniff. Nat Geog
Feb '94 p2–39
WEST (U.S.) - HISTORY
Goods Guys and Bad Guys of the Old
West. D.P.George. Boys' Life
Jul '94 p22–25+
WETLAND CONSERVATION
Everglades on the Edge. N.Finton.
SuperSci Blue Apr '94 p10–15
Why Save Wetlands? (Poster) World
Oct '93 p16–17
WETLANDS
Down by the Riverside. (New Orleans,
Louisiana) J.E.Rinard. World
Oct '93 p15+
Environment: Wetlands Saved?
H.H.Dreyfuss. Sci World Apr 15 '94
p2
The Wonder of Wetlands. Cur Health
Nov '93 p14–16
WHALES: see also Humpback Whales;
Killer Whale; White Whale
The California Gray Whale Comeback.
Dolphin Log Jan '94 p2–4
Should Whales be Held in Captivity?
I.Wickelgren. Cur Sci Oct 15 '93
p12–13
Slurping Whales Snack on the Sea-
shore. A.Weitkamp. Dolphin Log
Jan '94 p5–6
The Walking Whales That Swam.
Dolphin Log Jul '94 p18
Whale Watching in 1994. World
Aug '94 p31
Whales Are the Largest and Among the
Most Graceful of Mammals. (Photo-
graph) Zoobooks Sep '93 p8–9
Whales with Legs?
See issues of SI for Kids
WHALES - FICTION
Annie and the Whales. S.E.Edwards.
Jack & Jill Sep '93 p10–14
WHEELS
Inventors' Workshop: Let 'Em Roll!
SuperSci Red Mar '94 p6–7
Making a Rolling Wind Wheel! (Poster)
SuperSci Red Mar '94 supp
Science News: Wheels in the News.
SuperSci Red Mar '94 p14–15
WHEELS - POETRY
The Wheel. J.Van Dolzen Pease.
SuperSci Red Mar '94 p12–13
WHISTLING
How Do we Whistle? S. & A.Gaunt.
SuperSci Blue Apr '94 p27
WHISTLING - FICTION
Whistle for Willie. E.J.Keats. Sesame
Mar '94 p20–21
WHITE HOUSE (Washington, D.C.)
Pets: White House Critters. M.Daly.
Boys' Life Jul '94 p15

TRANSPARENCY 3.8

40

MCDOWELL, JACK
 Press Conference: Jack McDowell Tells
 Fifth-Graders All about Pitching for
 the Chicago White Sox. SI for Kids
 Aug '93 p20–21
 Rock and Roll Pitcher. T.Gilbert.
 KidSports Nov-Dec '93 p28–29
MADAGASCAR
 Aaak! Eerg! Screech! Grunt!
 Dolphin Log Jul '94 p2–3
MAGAZINE PUBLISHING
 Behind the Scenes at Cricket. Cricket
 Sep '93 p28–34
 How do You Know All this Stuff?
 Chickadee Sep '93 p24–25
 Science World: In Living Color.
 K.McNulty. Sci World Feb 11 '94
 p8–12
MAGAZINES
 Old Cricket Says. Cricket Mar '94
 p64
MAGAZINES - REVIEWS
 Quantum. Odyssey Feb '94 p40–41
 Z Reviews: Magazines. Zillions
 Dec '93–Jan '94 p34
MAGIC - FICTION
 The Enchanted Loom. K.Donohue.
 Cricket Nov '93 p37–42
 The Magician's Rabbit.
 S.S.McPherson. Child Life Sep '93
 p32–35
 The Palanquin of the Goddess.
 D.Agarwal. Cricket May '94
 p28–33
MAGIC TRICKS
 Like Magic! Top Secret Magic Tricks
 You Can Do. D.Roper. Highlights
 Apr '94 p11
 Magic: Mixed-Up Magic. M.Miller.
 Boys' Life Mar '94 p6
 Magic: The Impatient Card. B.Severn.
 Boys' Life Sep '93 p9
 Magic: The Wholesale Card Trick.
 B.Severn. Boys' Life Aug '93 p11
 Now You see It, Now You Don't.
 K.Shively. Cricket Jan '94 p38–39
 Sherman's Favorite Magic Tricks.
 Child Life Sep '93 p36–39
 Supersonic Paper. Highlights Jul '94
 p34
MAGNETISM: see also Magnets
MAGNETS
 Brace Yourself: Here Comes Magnet
 Mouth. Cur Sci Nov 12 '93 p14
MAIL: See Postal Service
MAIL ORDER BUSINESS
 Mail-Order Merchandise: Worthy of
 Your Cash? or the Trash? Zillions
 Apr-May '94 p5–8
MAJERLE, DAN
 Stars - Dan Majerle: Guard/Forward,
 Phoenix Suns. J.Rolfe. SI for Kids
 Apr '94 p45

MAJMUDAR, GINA
 KidStar: A Tennis-Playing Scholar.
 W.Coffey. KidSports Sep-Oct '93
 p37
MAKEM, TOMMY
 Makem Music: An Interview. S.Mead.
 Cobble Mar '94 p36–39
MAMMOTH
 If Mammoths Lived During the Ice
 Age, What Did They Eat?
 L.E.Wolk. Owl Sep '93 p14
 Woolly Mammoth. (Poster) Owl
 Sep '93 p16–17
MAN - PREHISTORIC: see Prehistoric
 Humans
MANATEES
 Just a Few Questions, Please. (Photo-
 graph) World Dec '93 p2–3
 Manatees in the News. Ranger Rick
 Oct '93 p18–20
 Stamp-ede. Contact Mar '94 p3
MANKILLER, WILMA
 Wilma Mankiller. Bio Today Apr '94
 p91–99
MANNERS AND CUSTOMS: see also
 Holidays; Kissing
 Il Galateo (The Book of Manners).
 Calliope May-Jun '94 p39
**MANNERS AND CUSTOMS -
 POETRY**
 House on Parade. L.D.Chaffin.
 Hopscotch Aug-Sep '93 p28–30
MAP-MAKING: see Cartography
MAPS: see also Geography
 Alaska. (2-sided) Nat Geog May '94
 supp
 Boston to Washington: Circa 1830.
 Nat Geog Jul '94 supp
 Boston to Washington: Megalopolis.
 Nat Geog Jul '94 supp
 Epic Heroes around the World.
 Calliope Jan-Feb '94 p28–29
 Junior Scholastic World Atlas 1993–94.
 Jr Schol Oct 8 '93 p6–17
 The Making of Canada: Atlantic Cana-
 da. (2-sided) Nat Geog Oct '93
 supp
 The Moche's Peru. Faces Sep '93 p8
 The Mongol World. Calliope
 Nov-Dec '93 p22–23
 Rally of the Pharaohs. (Map of the au-
 tomobile race) Jr Schol Sep 17 '93
 p10–11
 Romulus and Remus. (Map of Ancient
 Rome) Discover Aug-Sep '93
 p10–11
 U.S. Atlas. Jr Schol Jan 14 & 21 '94
 p16–19
 A World at Risk: Take a Look at Three
 Problems Facing Our Planet.
 Jr Schol Apr 15'94 p10–11
 The World of Judaism. Calliope
 Mar-Apr '94 p5

T<small>RANSPARENCY</small> 3.9

40

DOGS - FICTION (cont.)
Scrap Visits the Doctor. K.K.Miller.
Playmate Oct-Nov '93 p16–20
DOGS - POETRY
Curtailed. J.B. Hargett. Humpty D
Jul-Aug '94 bc
Everyone's Best Friend. S.Sweeny.
Sesame Jun '94 p25–26
My Puppy. A.Fisher. Ladybug Feb '94
p23
Pretend You're a Dog. J.Marzollo.
Ladybug Feb '94 p24–25
DOGS - TRAINING
Your Dog Could be a Star. World
Sep '93 p6
DOGS, WILD: see Wild Dogs
DOLLHOUSES - FICTION
Molly and Emmett. M.Hafner.
Ladybug Mar '94 bc
DOLLS: see also Paper Dolls
Rose O'Neill and the Kewpies.
S.Currie. Cobble Jun '94 p21–23
DOLLS - JAPAN
Touch-Me-Not Dolls. S.Fox.
Hopscotch Feb-Mar '94 p46–48
DOLPHINS: see also Killer Whale
Atlantic Spotted Dolphins. (Photo-
graph) Nat Wildlife Apr-May '94 fc
Bottlenose Dolphins. (Photograph)
Nat Wildlife Dec '93-Jan '94 p52
The Dolphin: Alien Intelligence on
Earth. N.Day. Odyssey Sep '93
p30–31
Dolphin Catch a Wave. J.Myers.
Highlights Oct '93 p34–35
Dolphins Use Their Heads.
A.Biederman. Boys' Life Mar '94
p13
Marine Marvels. Kid City Jun '94
p10–13
Thinking about Dolphins. (Includes
photographs) M.Wexler.
Nat Wildlife Apr-May '94 p4–9
DOLPHINS - FICTION
A Friend in Need. M.Lannamann.
Jack & Jill Jul-Aug '94 p4–8
DONKEYS
Snow White and the Schnauzer.
C.Quillen. Hopscotch Apr-May '94
p42–45
DONKEYS - FICTION
Just Say Whoa! E.Pageler. Highlights
Sep '93 p40–41
DORSETT, TONY
Sports: Football Hall of Famer Tony
Dorsett. M.Peterson. Boys' Life
Aug. '94 p10
DOVE, RITA
Rita Dove. Bio Today Jan '94 p45–46
DOWN'S SYNDROME: see also Burke,
Christopher
Born Different. Cur Health Mar '94
p17–19

DOWN'S SYNDROME (cont.)
Meet Krista. M.Costello. Playmate
Jul-Aug '94 p10–12
My Page. S.Stragalas. Choices Jan '94
p17
DRAGONFLIES
Attack of the Dragonflies. Cur Sci
Dec 10 '93 p14
Dragonfly! (Includes photographs)
Sciland Apr '93 p17–18
Zoom Along. Dragonfly! J.A.Harvey.
Cricket Jul '94 p35–37
DRAGONFLIES - POETRY
Mystery Pilot. B.Wadewitz. Child D
Jun '94 p31
DRAGONS
Do You Believe in Dragons? R.Gray.
Ranger Rick Oct '93 p21–29
DRAGONS - POETRY
The Gold-Tinted Dragon. K.Kuskin.
Highlights Oct '93 p2
DRAMA: see Plays
DRAMA THERAPY
Art, Drama, and Music Therapists:
Helping Others though the Creative
Arts. J.Goldberg. Career World
Jan '94 p28–31
DREAMS
Why Do We Dream? C.Wilson.
Contact Sep '93 p5
DRESS CODES
Should Schools Ban Hats? Cur Ev
Mar 7–11 '94 p3
When Are School Dress Codes Okay?
Cur Ev Nov 29-Dec 3 '93 p3
DREXLER, CLYDE
The Worst Day I Ever Had: Oops!
Clyde Drexler Brought Two Right
Sneakers to a Dream Team Prac-
tice! C.Drexler. SI for Kids Aug '93
p48
DRINKING PROBLEM: see Alcoholism
DRINKING WATER
How Safe Is Our Drinking Water?
H.Westrup. Cur Sci Mar 25 '94
p8–9
How Safe Is Your Water? (Poster)
Cur Health Apr '94 supp;
Cur Sci Mar 25 '94 supp
Tapped Out! Why We're Running Out
of Water. Contact Jun '94 p16–19
DRINKS: see Beverages
DROPOUTS - PROGRAMS
Is Boot Camp the Answer for Drop-
outs? Cur Ev Sep 13–17 '93 p3
DROUGHTS - FICTION
The Laughing Clouds. M.Cherry.
Jack & Jill Jun '94 p32–35
DRUG ABUSE: see also Alcoholism;
Phoenix, River
The Dangers of LSD. Cur Health
Dec '93 p26–28
Drug Use Among Teens Rises. Cur Sci
Mar 25 '94 p14

TRANSPARENCY 3.10

(Reprinted with permission of R.R. Bowker, A Reed Reference Publishing Company from *Children's Magazine Guide,* volume 46, Number 10, © 1994, by Reed Elsevier, Inc.)

29

CHORAL SPEAKING (cont.)
I Met a Little April Fool. R.Bennett.
Plays Apr '94 p52
Memorial Day. A.Fisher. Plays
May '94 p57
Starting from Scratch. A.Fisher. Plays
Oct '93 p53
CHRISTMAS: see also Christmas Deco-
rations
Spicy Memories of Gingerbread Ann.
E.A.Uhlmann. Hopscotch
Dec '93–Jan '94 p19–21
CHRISTMAS DECORATIONS
Apple-Cinnamon Cutouts. World
Dec '93 p28
Away in a Manger. (Nativity scenes)
N.de Messiers. Highlights Dec '93
p37
Felt Roll-Ups. World Dec '93 p29
Have a Ball! World Dec '93 p28
CHRISTMAS DECORATIONS -
FICTION
Molly and Emmett. M.Hafner.
Ladybug Dec '93 bc
Tom and Pipp. H.Oxenbury. Ladybug
Dec '93 p2–6
CHRISTMAS - FICTION: see also San-
ta Claus - Fiction
Agnes and the Christmas Puppy.
F.B.Watts. Playmate Dec '93
p40–45
The Better-Than-Nothing Christmas.
L.Wohlers. Child D Dec '93 p40-45
Colin's Christmas Candle. B.Raftery.
Child Life Dec '93 p42–45
Early on Christmas Morning.
L.Lamplugh. Cricket Dec '93
p29–33
Elmer Cat's Christmas Gift. B.Killion.
Hopscotch Dec '93-Jan '94 p35–37
The Little Drummer Boy. P.Wagner.
Boys' Life Dec '93 p46–49
CHRISTMAS GIFTS: see Gifts
CHRISTMAS ORNAMENTS: see
Christmas Decorations
CHRISTMAS - PLAYS: see Plays
CHRISTMAS - POETRY
An Acrostic Christmas. B.N.Slate.
Playmate Dec '93 p18
Christmas in the Sun. M.Mahy.
Cricket Dec '93 p12
CHRISTMAS TREES - FICTION
Matt and Big Dog: The Christmas
Tree. M.H.Delval. Ladybug
Dec '93 p32–35
CHUNG, CONNIE
Connie Chung. Bio Today Jan '94
p38–44
CHUNNEL
"Chunnel" Completed: Britain and
France Linked. (Includes map)
Jr Schol Apr 8 '94 p8–9

CHUNNEL (cont.)
The Light at the End of the Chunnel.
C.Newman. Nat Geog May '94
p36–47
A Tunnel under the Sea. M.Henricks.
Boys' Life Oct '93 p18–21
Under the Channel. J.Horsfall.
Humpty D Dec '983 p24–28
What's a Chunel? World May '94
p32
CIDER - POETRY
Cider Time. S. Liatsos. Child D
Oct-Nov '93 p2
CIGARETTES: see also Smoking
Cigarette Advertising: Does It Target
Teens? Cur Ev Dec 6–10 '93 p3
Cigarettes Branded as Drug. Cur Ev
Mar 14–18 '94 p3
CIRCUS: see also Amusement Parks; Cir-
cus Performers
Circus Kids. E.Egan. SI for Kids
Jul '94 p58–61
Greetings from Idaho. (Poster) Sesame
Apr '94 p16–17
What's It Like to Be in the Circus?
Sesame Apr '94 p28–29
CIRCUS - FICTION
Bert and Ernie at the Circus. R. &
L.Ginns. Sesame Apr '94 p4–5
Felipe the Brave. S.Sweeny. Sesame
Apr '94 p20–22
CIRCUS PERFORMERS
Life under the Big Top. B.F.Backer.
Highlights Jul '94 p22–23
She Flips for the Circus! Kid City
Jun '94 p6–7
CISNEROS, HENRY
Henry Cisneros. Bio Today Sep '93
p42–48
CITY LIFE - FICTION
Tanya's City Garden. M.Dionetti
U*S*Kids Apr-May '94 p10–14
CIVIL RIGHTS: see also Blacks - Civil
Rights; Carter, Jimmy; Children's
Rights; Dalai Lamas; Students Rights
American History: Human Rights
Times - The Struggle for Rights Be-
fore the Civil War. S.Price. Jr Schol
Dec 3 '93 p11–13
Children: The Youngest Victims.
S.McCollum. Jr Schol Dec 3 '93
p8–10
Human Rights. (2-sided poster)
Jr Schol Dec 3 '93 supp
What Are Human Rights? Jr Schol
Dec 3 '93 p2–3
What You Can do. Jr Schol Dec 3 '93
p15
The World Crisis in Human Rights.
Cur Ev Mar 14–18 '94 p2a–2d

TRANSPARENCY 3.11

Chapter 4

Introducing Electronic Storage of Information

INTRODUCTION

Electronic storage of information is a given in the lives of our students. They encounter computers at stores, on their TV screens, and in dozens of other daily applications. It is teachers, librarians, and administrators who may feel anxious about computers as we first experience them in our own workplaces.

The language of technology can be initially mystifying until it is accepted as another way to express age-old concepts of information storage, accessibility, and use. Information becomes data; catalogs, indexes, encyclopedias, etc., become databases; questions become queries; subject headings become descriptors; finding what you're looking for becomes information retrieval; and students become information seekers or end-users! We must remember that students are learning this new vocabulary at the same time that they are learning traditional library terminology.

Schools across the nation are using technology to further the curriculum. Computer databases, CD-ROMs, and laser disk programs are now widely available (Miller 1993). (See Appendix B for a selected list of stand-alone database software and of commercial services.) The impact of library automation on student use of resources is tremendous, and the line between library media center and classroom is blurring. Online catalog use, both in the school and via modem, will be explored in Chapter 5.

This chapter provides only a brief introduction to the concept of electronic storage of information. Mastery of the basic search word strategies and of the think-aloud, problem-solving approach presented herein will prepare students for success as they reach out beyond the walls of their own school building.

STUDENT OBJECTIVES

1. The student will view databases as finite collections of information presented in a recognizable, unique format.

2. The student will view the library media center as a repository of many databases, including both traditional print and electronic storage.

3. The student will recognize the basic vocabulary of database management.

4. The student will articulate the parallels between manual and electronic search.

LESSON 1 (NARRATIVE): DATABASES—COMPUTERS HOUSE INFORMATION

Lesson Objective

The student will define "database," and will understand that libraries contain both print and electronically stored information.

Materials Needed

Display the following: a card catalog drawer (or picture of the online catalog display), an encyclopedia volume, an almanac, an issue of *Children's Magazine Guide*, a telephone directory, and the program disk for a database management software package. (See Appendix B for suggested database programs.) Each student will need a four-by-six-inch index card.

Motivating Activity

What do all these things, including me as library media specialist [or teacher], have in common? [Discuss student responses with the class.]

Presentation

In this lesson, we are going to learn a new term: "database." A database can be defined as a collection of information that has certain limits and employs a consistent format or arrangement. We are borrowing this word from computer vocabulary, but could it apply as well to the resources we have recently discussed?

Think of the library catalog. What is stored in this database? (*Information about the books and media in this library.*) What specific information does it give us? (*Authors, titles, illustrators, publishers, copyright dates, paginations, call numbers, content summaries, etc.*) These are bits of information we can expect to find in the library catalog. We also know what we cannot expect to find. As a database the catalog has certain limits.

Children's Magazine Guide can be described as a database. What information is stored within its covers? (*Information about magazine articles, including titles, authors, periodicals, issues, page numbers, etc.*)

What is stored in an encyclopedia volume? (*Printed articles on a particular subject.*) How is this database different from the library catalog database? (*The needed information is right there; the library catalog gives only a reference, and the material still has to be gotten and examined for its content.*)

What information is given in the yellow pages database? (*The names, addresses, and phone numbers of businesses, services, and sometimes of individuals.*)

We will turn our attention now to information that is electronically stored. Computer technology has added new searching possibilities to the traditional paper sources libraries have always provided. You are familiar with computer disks, compact disks, and video laser disks. These are all electronic media that can hold information, either bits of information or the full text of books, magazines, etc. Remember, though, that human beings gathered this information, decided what to include, tried to make it accessible to you the user, and stored it electronically.

To obtain information, you must still consider your question or task carefully. You must still do a search. You will be inputting certain commands to the machine. You will be retrieving information from the database if your search is successful. These steps involve the same techniques we use with a manual search in print indexes and materials, but they are called by different names. So, what you have learned

about subject search word strategies and about thinking aloud as you search will continue to help.

To understand fully how a database is put together and how it works, we will do a paper-and-pencil exercise first, then dramatize it. To get ready, we will do some "data entry." [Distribute blank index cards and have students complete the information about themselves as described in the sample.]

Database "Record"—Sample Card

 (Leave top line blank)

1. *Name:* _____ _____
 Last name First name

2. *Address:* _____
 Street address

 _____ _____ _____
 City State Zip

3. *Birthday:* _____ _____ _____
 Month Day Year

4. *Homeroom teacher:* _____
 Last name only

5. *Favorite subject:* _____

6. *Hobby:* _____

7. *Family Pet:* _____
 Dog, Cat, etc., None

We could have gone on and on adding bits of information about ourselves. We could have included favorite food, favorite TV show, favorite author, etc., but this is enough to demonstrate databases. What we have now is all these individual index cards. We will see in our next lesson how this information could be stored in a computer and the various ways we could retrieve it.

Closure

Can someone give us the term meaning "the getting of information out of a database?" (*Retrieval or retrieving information.*) Can you use this term in a sentence about libraries in general? (*Libraries have many resources that can be retrieved by users.*) Information is stored in many forms. New technologies are being perfected constantly to make ever greater quantities of data available. The thinking person knows that this information can be accessed if attention is given to the organization of the particular database that stores it and a systematic search process is used.

LESSON 2 (NARRATIVE): DATABASES—COMPUTERS HAND IT OVER

Lesson Objective

The student will define basic database vocabulary and demonstrate the concepts of sort, select, and display.

Materials Needed

Include completed index cards from the previous lesson and a standard card-file container.

Motivating Activity

> [Hold up the card-file container.]

What is this object called? (*A file or file box.*) What is stored inside this file? (*Index cards with information written on them.*) In the last lesson, each of you contributed information about yourself that we now have on file. You have created a database, which is an organized collection of data.

Most of the time, files are given names that describe their content. This file has become a database, so what could we name it? [Consider suggestions and decide on a name: student address file, student information file, Ms. Smith's class, etc.]

Presentation

Our little file box is a traditional container for storing cards. For many generations, people have organized information and kept it accessible by using such a system. In a computer database, however, we do not see the file because it is stored electronically. We give a command by typing on a keyboard what we want from the file, and then we see the information displayed on the screen in front of us. And with the computer, we are able to find bits of information quickly and rearrange the information without rearranging the cards. Let's see how this works.

We need some new vocabulary to help us be more precise when we talk about database management programs. Each of these index cards can be called a "record." Each of these records contains certain information, and each is unique because you entered facts about yourself. But the categories of information were the same for all of you. Each category, or type of information recorded, is called a "field." Who can name some of the fields we used? (*Student's name, address, homeroom teacher, etc.*)

> [Show transparency 4.1]

Look at this example of our three new words: file, record, and field. The file in this picture is named "Address Book." Each record in the file tells us about a different person. Each of these records has four fields which separate and hold the information about the different people in the address book.

> [Show transparency 4.2]

But back to our database in progress. We decided on the file name, ("Ms. Smith's Class"), so we will add that to our diagram. I want you to count off so that each person has a number. When I give you

your index card, write the word "Record" and your number in the middle of the top line above your name, just as in the example. Each of you is now one of the records in our database. How many records do we have? In the "Address Book" example, there were only four records indicated, but we have many more. What happens if we get a new student? (*We can add a new record to the file.*)

The earlier example also included only four fields on each record. We stopped with seven fields. On your record, underline each field name. Do not underline the data, or information. Just underline the field name, or category. Notice that your "address" is only one field although we wrote the information on more than one line.

Notice, too, that no field name is more than twenty characters long. Again, this is a limit we will often find in real computer database programs. We will find, also, that we are limited in the amount of data we can include for each field. The information we write beside the field name is called the "field value." Think about the times you have been asked to print your name in little boxes on a machine-readable form. Even the spaces between your last name, first name, and middle name get counted as characters, so sometimes the limit was reached before you got your complete name entered.

Let's think now of how a computer can move this information around inside its memory, reorganize it, and give us back what we ask for. Think of yourselves as the records in the file stored in the computer. You are in random order now because of the way in which you are physically arranged in this room. We could ask the computer to sort through the records and to arrange you in alphabetical order by last name. We could ask it to sort the records and to list you in order by the month of your birthday. There are many possibilities.

We will dramatize this with an activity I call "Database File." Everyone is to stand and to hold your card facing out so we can see the information you have written on it. You are going to move your record, and yourself in this case, according to the commands I give the computer. We are manipulating the records, not by keyboard strokes, but by my voice. [Allow students to assemble in an open space in the room.] First, I want to sort you in alphabetical order by last name. So, as I call out last names, line up in front from left to right and we will display you.

Now we will do a different "sort." We will ask the computer to sort you according to the month in which you were born. Let me have January birthdays here, February birthdays here, etc. Once you have found your birthday group, arrange yourselves alphabetically by last name within the group. We have sorted and displayed all our records. Do you see how all the fields of information move around with the record. We could sort you in all kinds of ways, but the information about you stays constant—it is attached to the record.

Now that you understand "sort" and "display," we will add another command used in database management programs—"select." This means all the records will be searched, but only those with certain information will be selected and displayed. Let's see how this works. It doesn't matter how you are arranged now because we are pretending that you are inside the computer's memory and we can't really see you.

[The following paragraph applies only if students represent at least two different homerooms.]

When I ask the computer to select and display records that contain a certain homeroom teacher [call a name that is certain to be represented] as a field value, those of you in that homeroom step forward three steps; those of you not in that homeroom remain in place. This demonstrates how the computer can select records from a database. It brings forward only those records matching the command.

Jumble yourselves together again. This time we will ask the computer to select by two fields and display the results. Will all you "records" whose favorite subject is math and who have a dog as a pet please take three steps forward. Did we get any "hits"? [If no one steps forward, try a different combination of field values. After the exercise, any students who stepped forward should remix.]

Let's have another demonstration using different fields. We want to select all records with May birthdays that have ballet as a hobby. [The instructor will have noted prior to the lesson that no records satisfy this request.] Where is our display? No one stepped forward. Certainly this can happen in a computer search as well. A message will appear on the screen that says "Zero records selected," or something like that.

Everyone be seated, and we will review what has been demonstrated with this activity.

[Show transparency 4.3]

"To sort" means to arrange the records according to one field. "Select" allows the user to find records containing specific information. None of this information will be visible on the screen unless the computer is told to "display" all or part of the record. In our demonstration, we displayed the entire record each time because we were holding the card with all the information visible. We could have asked for either the entire record or only a designated field to be displayed. For example, we could have asked the computer to select students who have January birthdays and to display only their names.

Check for Student Understanding

How are traditional index files similar to a computer database? In our dramatized computer database, could we have sorted our records by boys and girls? Why? (*No, because we did not create that particular field in our original record.*)

Closure

Creating records for a database file requires deciding on the fields that will be included, then inputting the data or field values. Once the fields have been set up, records can be added as needed. Gaining entry into the records and retrieving information from them occurs when the computer is given commands such as sort, select, and display.

[Note to the instructor: Subsequent lessons can be designed to introduce students to particular database management systems available in their classroom or library media center. I believe that the dramatization activities in Lesson 2 help young people grasp abstract concepts of information retrieval and ultimately will reinforce their understanding of the relationship between search query and indexing terminology.]

LESSON 3 (DESCRIPTIVE): CD-ROM/ONE-STOP SHOPPING?

Background

Electronic encyclopedias and other subject-specialized CD-ROM products may now be found in many school library media centers. Beyond the obvious need for orientation lessons to operate a particular program, there is a need for guidance on effective use of this medium in relation to other forms of information storage, both traditional and technological.

Articles are appearing in the library and information science literature that provide insights into student behavior with electronic searching and point out the potential for CD-ROM storage and retrieval systems (Marchionini 1989; Liebscher and Marchionini 1988).

Companies producing CD-ROM software often provide excellent supplementary materials to use in developing student lessons and guided activities. Examples of such materials are *Compton's MultiMedia Encyclopedia: Lesson Guide for Social Studies Excursions* and *Compton's MultiMedia Encyclopedia: Researcher's Assistant Guide* (Carlsbad, California: Compton's NewMedia, 1990–92).

Lesson Objective

The student will understand both the potential and the limitations of CD-ROM software as an interactive medium for storage and retrieval of text, picture, and sound.

Motivating Activity

Ask one student to locate the article "Snakes" in the print edition of *Compton's Encyclopedia*. Simultaneously, have another student locate the same article in *Compton's MultiMedia Encyclopedia* on CD-ROM continued as *Compton's Interactive Encyclopedia*. Ask the students to show that the information and illustrations are essentially the same in the different formats. Acknowledge that one may be more fun to use.

Remind them that they must evaluate what they read in either format for the accuracy, point of view, and possible bias of the authors.

Point out that while the print version of the encyclopedia contains cross-references in its index volume and within its articles, the CD-ROM version has additional keyword and phrase options—"Idea Search"— that demonstrate the program's power to link topics and to locate relevant information imbedded within many articles.

Explain that when one examines the relationship of references resulting from an Idea Search in the electronic encyclopedia, the concept of overlapping subjects as a search word strategy is reinforced. Point out that when using this format in a reflective manner, the student may discover ideas for searchable terms to try in other information sources as well.

Description of the Activity

> [This activity is of intermediate difficulty and requires an overlapping-subjects strategy using *Compton's MultiMedia Encyclopedia,* Compton's Learning Company, 1993.]

Ask the student to locate a map showing the Santa Fe Trail. Assure the student that such a map is in at least two articles. Giving the map's title, "Some Historic American Roads and Trails," may provide a clue for search terms; other clues may also be given as needed.

If the Title Finder option is used, neither **Santa Fe Trail** nor **Trails** produces a result, because there are no actual encyclopedia articles with these titles.

If the Idea Search option is used, **Santa-Fe-Trail** (with two hyphens) produces no results; **Santa-Fe Trail** (with only one hyphen) locates the appearance of those words or the phrase in over a hundred articles! The articles most likely to contain the information are starred and appear first in the list.

Ask the students to review the Idea Search list of articles found, and they will notice such overlapping subjects as **Santa Fe, N.M., Frontier, United States History, Oregon Trail, Wild Bill Hickok, Cowboy, Kit Carson,** and **Roads and Streets.**

Have the students check under the **Frontier** article in its section called "The Great Santa Fe Trail." There is much information, but no map.

The students should continue to search until they locate the map, which is included in both the **United States History** article in its section, "The Frontier Crosses the Mississippi," and in the **Roads and Streets** article in its section, "History."

Closure

An electronic encyclopedia may be the student's first experience with a computer's capacity for providing indexing and full-text articles. Because of "technology mystique," an electronic encyclopedia has the aura of infallibility. As always, remind the students that they will benefit from a thinking approach to the format and to the stored data in this as with any information system.

FILE: ADDRESS BOOK

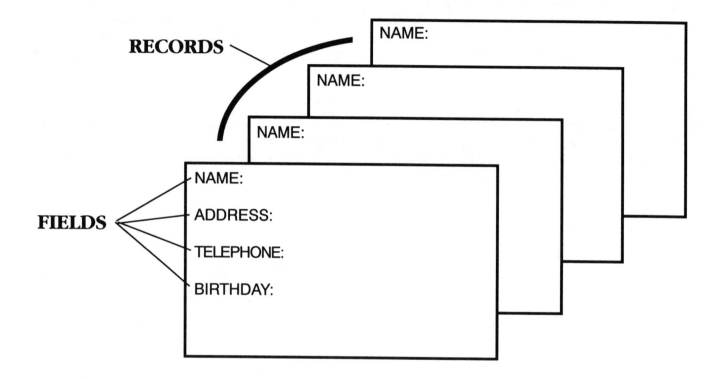

A FILE is defined by its FIELDS. Once you have created a FILE by defining (or naming) its FIELDS, every RECORD in that FILE will have the same FIELD names. For example, you might create a name and address file. You define the following four FIELDS:

1. **NAME**
2. **ADDRESS**
3. **PHONE**
4. **BIRTHDAY**

TRANSPARENCY 4.1

(from *Friendly Filer* by Grolier Electronic Publishing, Inc. 1984)
Reprinted with permission of the Houghton Mifflin Company

FILE: _____

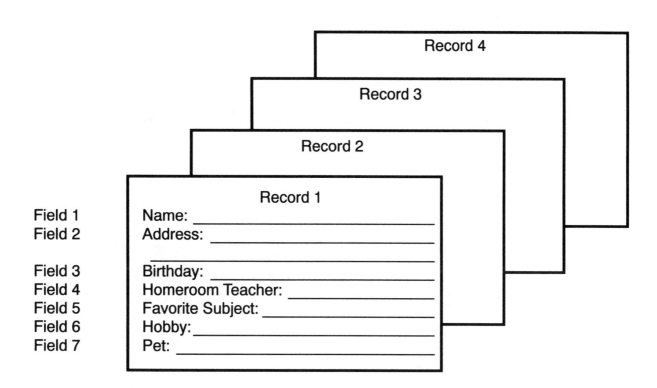

DATABASE SEARCH COMMANDS

SORT

> To *arrange* the RECORDS in a FILE according to one of the FIELDS.

SELECT

> To *search* through the file and find the *particular record wanted.* (Records may be selected by more than one field at a time.)

DISPLAY

> To *show* the requested information on the screen. (All or part of the record may be displayed.)

Chapter 5

Accelerated Access Through Automation

INTRODUCTION

Online catalogs not only make library resources accessible to students, they also provide an additional impetus for exploring the library and discovering information independently.

After twenty years as an elementary school library media specialist working with children and the card catalog, I witnessed firsthand the amazing phenomenon of automation. The earlier experience of students searching a distant library's online public access catalog (OPAC) via modem did not compare to the excitement generated by the installation of workstations in their own school library media center. Students of all ability and instructional levels hovered around waiting for a chance to search. I believe that their prior knowledge of, and comfort with, the collection, card catalog, and general environment favorably influenced student behavior. Beyond that, however, appeared to be the reassuring belief of these young Information Age students that the computer contains a direct path through what they perceive to be mile-high shelves of books to the information they want.

Particular design features of the online system will determine much of the lessons' content. Chapter 5 presentations should be modified for the particular database and student population. The instructor is encouraged to create new illustrative material from printed screens or from the system software producer's own manuals. (See Appendix C for transparency templates.)

The following lessons are built around the use of two online catalog systems: Winnebago Software Company, version 6.1, and Dynix, Inc. an Ameritech Company (see Murphy 1992, p. 66, for a "Directory of Automation Companies"). It is assumed that students will have a basic familiarity with their own library catalog when these lessons are undertaken. Because of their knowledge of database construction, students will approach a routine title search and author search with a new awareness of what is happening as the computer searches its records.

The lessons on subject search provide a basic introduction to students and must be expanded whenever a specific curriculum topic can be substituted in the examples. Any instructional unit should include an early discussion of key terminology and of potential linkages among subject entries. Such dialogue among teacher, library media specialist, and students will have positive impact on both the initial access phase and the hunting phase of an online search.

System design and the cognitive readiness of students will determine the need for developing additional lessons on keyword search and Boolean search options beyond the brief description in Lesson 5 of this chapter.

STUDENT OBJECTIVES

1. The student will recognize various search options provided by online library catalogs.

2. The student will extract bibliographic and cataloging information from an online library catalog.

3. The student will gain proficiency in refining a subject search by using subject search word strategies and a variety of online catalog search options.

LESSON 1 (NARRATIVE): ONLINE SEARCH BY TITLE AND AUTHOR

Lesson Objective

The student will utilize menus in an online library catalog to complete title and author searches. Bibliographic information will be extracted from the catalog card display screen.

Motivating Activity

Look around our school library media center for a moment and think about all the information, ideas, and pleasurable reading contained within these walls for your use! This library is yours. Yes, it was here before you became a student, and will still be here after you leave, but right now it is yours. It is also changing even while you use it. Every year we buy new books and media with you and your schoolmates in mind. Sometimes things get lost, and we cannot replace them. The big question is, "How do you ever know what's here and where it's actually located on the shelves?" Yes, you know the answer to that—our library catalog is the index to all the materials in this collection.

Presentation

This is not your first introduction to our computerized catalog, but we are going to relate its indexing function to your knowledge of databases and subject search word strategies. Let's consider how the computer stores the information about all these books and materials around us.

Take any two books such as these. [Hold up two different titles published by the same company.] In describing them, there are specific bits of information that make them unique. Obviously, their titles are different. They were written by different authors. It happens that their publishers are the same, but that could be just a coincidence. They were published in different years. The number of pages differs. Yes, the color of their covers differs. Their call numbers are different. It goes without saying that they are about different topics.

Has anyone been thinking; "Our library catalog is a database"? Each of these books around us is a record in that database. Each record contains certain information about the book—the information we have just been talking about.

Have you ever gotten to a screen at the workstation that had a lot of gibberish on it—letters, numbers, and little keyboard symbols? That was a display of the MARC (machine-readable cataloging) record for a particular book. This machine-readable data contains the structure for the fields and the cataloging information that has been filled in about an item. Remember our index cards a while back and how you created fields about yourself on them?

When we get new books for our library media center, we also acquire the MARC record for that book to add to our computer system. If this is not available for some reason, I have to input the data following the standard MARC format or arrangement. [See Zuiderveld 1991 for a concise introduction to MARC records.]

You've already figured out that there is a field for title information, a field for author information, etc. Some information is combined in a field, and some is not there at all—such as color of cover, because the color is not considered essential in identifying a work. It would be somewhat odd to ask the computer to search for all little red books of no more than thirty-five pages, although there might be times when all you remember about a book *is* its color and how short it was!

We will consider now two very common fields for searching: the title field and the author field. When we do a title search at the computer, it is important to remember that what we are really doing is using the title field to call up a record. We are trying to see if a certain title that we have in mind is in the collection, and, if so, who wrote it and where it is shelved.

When we do an author search—or search by author—we are asking the computer to take the author's name that we give it, search its database, and pull up all records that match the data in the author field. [In conversation, we often link the word "search" with the preposition "for"; this can be confusing to younger students. They know the author; hence, we are searching "by" author, not "for" author. It is important to make this distinction and verbalize the search task with them.]

Whenever you approach an online library catalog, you must first comprehend its opening screen, and then move into the search you are planning. Just as with any printed source, you locate the index, glance at headings, page layout, typeface, indentions, etc. This happens quickly and, with experience, almost subconsciously. Usually, computer screens have "help" options or directions of how to proceed displayed across the bottom.

We will be considering screens from our own school's catalog as well as from our public library's catalog to illustrate some of the visible differences. Remember, what's happening *inside* the computer is very much the same as when we sorted ourselves by the seven fields on our "Record" cards. [For a comparison of opening screens in twelve library automation companies, see Murphy 1992, p. 143.]

[Show transparency 5.1]

This is a picture of a title card from our old card catalog. It is the record of a still-popular fiction title, *The Cybil War.* Notice the order and placement of the bibliographic data on the card. Let's see how this information would look in an online catalog.

[The Winnebago Circ/Cat program opens with a "keyword search" screen, which some readers may leave as the opening screen; however, I suggest that in the initial transition period from use of a card catalog to an automated catalog, lessons be built around the "regular catalog" screens because of the students' familiarity with the three traditional modes of access: author, subject, and title.]

[Show transparency 5.2]

In our library catalog, we must press function keys as noted in the on-screen directions until we reach this screen where we are told to "Enter Title." We now type in the title we are seeking. Since our system ignores articles at the beginning of titles, we can either type "A," "An," or "The," or leave them off. So let's enter **Cybil War**.

If a record is found for the title, it will be included in an alphabetical list of titles from our collection. From this list, select your book and a card display will appear on the screen.

[Show transparency 5.3]

You can see that it has essentially the same information and format as the catalog card we just saw.

At our public library, which has a different brand of online catalog, we can check for this same book by doing a title search, and we finally get to this screen.

[Show transparency 5.4]

What are the similarities in the record display for these two automated catalogs? [Alternate transparencies 5.3 and 5.4. Discuss briefly.] What are the differences? [Discuss briefly.]

Let's see how the two systems differ when doing an author search. With our system, we use the function keys as directed until we reach the author search screen.

[Show transparency 5.5]

Since now we have found out who wrote *The Cybil War,* let's see what else this author has written that is available to us. Remember to type the last name—Byars—first. The computer will zip through every record in its database and locate all those with the name you gave it. Then it will display the name in an alphabetical list of authors.

[Show transparency 5.6]

You will be amazed to see that there are three screens full of her books. [Each screen has a limit to the number of lines.] Depending upon how many copies we have, some titles may be listed more than once.

[Show transparency 5.7]

Returning to the public library's opening screen, we select menu option listed as "Name/Author Search." This is the terminology they use to indicate an author search.

[Show transparency 5.8]

When we type **Byars, B.,** this is the screen we see. Is anyone wondering about that strange message, "Author may be truncated"? "Truncated" means cut off or shortened, so this is telling you that the computer has been programmed to search its database by the first few letters of the author's name. Enter as much as you can spell, then, and see what you get.

Check for Student Understanding

Let's consider a few questions that might clarify what we have seen. Certainly, it will become more clear as you practice doing these kinds of searches. How are card catalogs and computer catalogs similar? How are they different? Are all computer catalogs the same? What are some of the differences you have noticed from today's lesson?

Closure

We have been comparing what are called OPACs. This acronym stands for Online Public Access Catalog. All companies that design such systems try to make them user friendly. They attempt to give clear directions, and they provide "help" screens, but the screens can look very different.

All library catalogs, no matter what their design, are intended to serve as an index to their library's collection. Our public library OPAC represents a networked catalog for the main library and all its branches. Our school catalog is networked to each student workstation and to our circulation and office computers, but the database is limited to this library. In the near future, however, the district will have

what is called a "union catalog," so that we can find out what is available in all the school libraries, not just our own.

It is possible to connect library databases in various ways, including the use of a modem connected to a telephone line. This will be a topic for another lesson. Those of you who have modems at home will have a lot to share with the class.

In closing, let's recall our five search word strategies and apply them to the questions, "What books do we have by Betsy Byars?" and "Who wrote *The Cybil War*?" These could be considered simple keyword questions. **Byars** is the keyword in the first question; **Cybil War** in the second. If you select a computer database as your information source, you will see, however, that the phrase "keyboard search" can have a slightly different meaning depending upon the system design. Don't be confused by this. We have emphasized the importance of thinking through a question. This will always be the first step in your investigation. How a particular computer program is set up to handle inquiries is quite a different issue. For now, keep practicing and discovering on your own.

LESSON 2 (NARRATIVE): COMING TO TERMS WITH ONLINE SUBJECT SEARCHING

Lesson Objective

The student will utilize menus in an online library catalog to complete subject searches.

Motivating Activity

In our last lesson, we reviewed the procedures for doing a title search and an author search in an automated library catalog. Now we will add subject searching, which will really give you a chance to practice all your search word strategies and acquired skills for using indexes.

Presentation

Again, we would expect the opening screen of different online systems to look different, yet clearly to offer the option for subject searching. What may not be immediately apparent is how the system accepts subject search terms—that is, what are the limits of a system's subject authority? Will it accept terms in random order, or does it require that terms be entered in a certain form including the punctuation? Be prepared to undergo some trial-and-error learning when you approach a system that is new to you; be sure to ask questions and to think aloud as you go along.

We will look first at our OPAC's regular catalog search option and see what we can pull up on the topic of **Oceans**. In searching a collection of our size, we wouldn't expect to find an overwhelming number of references on this topic, but in a public library or university library, there might be hundreds of titles relating to oceans. In a true assignment, you would have in mind more clearly what you are looking for and would have brainstormed a lot of possible search words. Surveying your topic first and doing several narrower searches might be a more efficient way to examine likely material. To illustrate some important points, however, we will do it this way for now.

> [Show transparency 5.9]

At this screen, it is a simple task of typing the word **Oceans**.

You might be interested to know that when the subject list is displayed, **Ocean** is in its singular form. Selecting that term from the list gives us a new listing of several titles. Let's examine them:

> [Show transparencies 5.10, 5.11, and 5.12 briefly]

By looking at the tracings on each card display, we see that **Ocean** seems to be the broadest term assigned to each of these records.

> [Show transparency 5.10]

Only one has **Marine Animals** as a heading. We will save this term to use in a moment for another search. Both the title and summary note for *The Magic School Bus on the Ocean Floor* give us an idea of its reading level. In *I Am the Ocean*, there are several indications that suggest it contains less complex information than some of the other books. For instance, "unp" (meaning that the pages are not numbered) suggests that it is not a very long work. And, although we may not know the definition of

"paean," the summary note suggests a poetic mood piece. We would want to examine the actual book for its usability in a real-life task.

[Show transparency 5.11]

These books have an additional heading, **Marine Biology**, which is more specific than **Ocean**. **Marine Biology** is another term we will try later.

[Show transparency 5.12]

Because of the descriptive title that Bright gave his book, we might expect to see the assigned subject headings **Marine Pollution** and **Marine Ecology**. Even though no summary is given, the work's content seems clear. You may wonder, though, why the term **Marine Ecology** was not used for the Simon book since its annotation speaks of the "fragility of the world's oceans." Perhaps the cataloger believed that ecology was not a major emphasis of the book.

If we enter the different terms we picked up from the tracings, we would find the following in our library collection [instructors should substitute numbers reflecting their collections]:

16 books are indexed under **Marine Animals**
12 books are indexed under **Marine Biology**
 2 books are indexed under **Marine Ecology**

Of course, this does not mean that there are thirty different books on these three topics in our library media center, because some of them are indexed in more than one way.

[Show transparency 5.13]

Since I knew our library had this book, I retrieved its record in order to show you the assigned subject headings. Can you see how easily it might have been missed if you had not thought to look up the overlapping topic of **Oil Spills** when doing a search for information on ocean pollution?

[Depending on the length of the class period, students should be allowed hands-on time at the workstations. They could select topics of personal interest; structured questions could be created; a group relay competition could be held; etc. Effort should always be made to have students physically do something with the information presented by the instructor.]

Closure

As you do more and more subject searching for assignments or through personal interest, you will discover the remarkable possibilities of online systems. Remember that these systems and their databases were designed by human beings; they will not be perfect. If you notice errors or have suggestions for a wider range of subject headings, let me know because I can make corrections and add headings. Catalogs exist to expand access to our materials, and librarians work to make your access better.

LESSON 3 (NARRATIVE): WHEN THE SUBJECT IS BIOGRAPHY

Lesson Objective

The student will use an online catalog to locate individual and collective biographies.

Motivating Activity

In your social studies and science units you may have been asked to do outside reading about famous individuals who have made a special contribution to their fields. If you need brief, concise information, encyclopedias and other reference books would be the place to look first. For more in-depth coverage, a complete biography may be what you need. Another option is a collective biography. It may take a bit of detective work, however, to discover if a section on your person is included in such a collection.

Presentation

In this lesson we will look at how to retrieve records of biographies from an online library catalog.

[Reshow transparency 5.7]

In our public library OPAC menu, the "Name/Author Search" option is used for both an author search and for a biography search. So, if we want to find a biography of the famous African American Mary McLeod Bethune, we enter selection 2 and type her name when asked to do so.

[Show transparency 5.14]

In this transparency, we see a partial list of the titles found. The screen tells us that the search produced fourteen hits. Let's examine the card display for one of them.

[Show transparency 5.15]

Notice that this system uses the word "Topics" to label the subject headings that have been assigned to a book. Let's compare what we see here with what we found on the old catalog card for the same title.

[Show transparency 5.16]

Do you notice that, in addition to the individual's name as a subject entry, there is an entry under **Blacks—Biography**? In the online catalog, we saw this same book indexed under **Afro-Americans— Biography**. If you remember our discussion on how a library's subject headings can change over time, you can see how necessary it is to check under a variety of terms. A good rule of thumb in searching is to begin with the most specific term, which in the case of biographies is the individual's name.

[Show transparency 5.17]

Notice in this transparency, which shows both an old catalog card and the online card display, what would have happened if we had searched under **Blacks—Biography** or **Afro-Americans—Biography**. In the online catalog would we have found this book about George Washington Carver? (*No, neither of those phrases is used there.*) If we had expected to find the book listed in the catalog because we had remembered seeing it before but couldn't recall the unusual title or the author, we would have been puzzled. We might have thought to enter the term **Peanuts** if we had used our overlapping subject search strategy, and we would have found the book in either catalog. But, still, the surest approach is first to try Carver's name.

In using the online catalog in our library media center, you will need this same sort of flexibility in thinking that we have just seen. To search for biographical material in our system, we use the "Subject Search" option. It is logical to think of the person as the subject of a book.

[Reshow transparency 5.9]

To determine if we have a biography of Supreme Court Justice Sandra Day O'Connor, for example, enter her name as subject, last name first. Our library catalog displays a partial subject list, and in it we find her name, which tells us that in our collection there is at least one book dealing with her life.

[Show transparency 5.18]

Notice that the year of O'Connor's birth is given in the subject listing.

[Show transparency 5.19]

In this partial list of subjects you should see two individuals listed. Who are they? Can you explain the difference in how their names appear? (*The English naval commander and explorer is known as Sir Walter Raleigh, and his title is included in the entry. The great Italian painter is known to us only by the one name, Raphael.*) Why might the question mark be included in one of the dates? (*Historians are uncertain of this date.*)

[Show transparency 5.20]

If you select the name Robert Scott in this subject list, you probably expect to find an individual biography displayed.

[Show transparency 5.21]

What we find instead, is a book about the Antarctic expedition in which he took part. Notice that this book is not classified as biography, but rather has a call number 919.8/SWA.

It would be very helpful if all books that include sections on famous people also include separate catalog entries under their individual names, but this is not the case.

[Reshow transparency 5.20]

Notice the subject entries again. Both **Scientists** and **Scientists—Biography** appear. Let's see why.

[Show transparency 5.22]

Here is an example of a "collective biography." It contains many brief biographies of important scientists. This book was assigned only the subject head **Scientists—Biography**. [This term is no longer used by catalogers, but instructor may find older copyrighted materials that did include it.] Unfortunately, many collective biographies that contain even sizable amounts of information about a person are not indexed by the individual's name. For example, if we entered Thomas Alva **Edison** in a regular subject search, we would not see any reference to this collective biography. [When using the keyword search option in Winnebago CAT, collective biographies will be found as long as the individual name appears in the record's note field and the note is a source selected by the user.]

[Reshow transparency 5.20]

The term **Scientists** may have been used for a book about a particular scientist in addition to the person's name as subject. Many biographies have not been indexed with this term, however, so selecting the term from the subject list in no way shows us all of the library's books about scientists.

[Reshow transparency 5.17]

Think about the Carver book we saw earlier. Carver certainly was a scientist, yet the broad subject heading **Scientists** was not assigned for this book. More specific terms, **Agriculture—Biography** and **Agriculturists—Biography**, were used. The term **Botanists—Biography** may also be used for some biographies of George Washington Carver.

Closure

Searching an online catalog for biographical works can stretch your thinking but is not really difficult. It appears from our few examples that there may be inconsistencies in the way the database has been created. But keep thinking of alternate ways to search; make sure you have been thorough. Keep asking yourself, "What if I do this?" and "What if I do that?" Getting the online catalog to reveal its wonders can be very rewarding.

LESSON 4 (DESCRIPTIVE): KEYWORD SEARCH—WIDENING THE POSSIBILITIES

> [A descriptive rather than narrative approach to the lesson is given since the instructor's OPAC design and application are essential to the presentation. The following illustrative materials are drawn from the use of Winnebago Circ/Cat, version 6.1, in which "keyword search" is the first option. Prior to this lesson, the second option— "regular catalog"—was used. I chose to concentrate on a traditional author-title-subject search to facilitate the transition from use of a card catalog to an online catalog.]

Lesson Objective

The student will understand that "keyword search" as used by Winnebago Circ/Cat differs from "keyword search" as a user's thinking strategy—one of the five search word strategies. The student will view Boolean operators as providing a means for limiting a search.

Motivating Activity

[Show transparency 5.23]

Ask students to hypothesize how this title list was generated. (*The list represents a subject search using the term "Robots" in the regular catalog of Winnebago.*)

[Show transparency 5.24]

Ask students to hypothesize how this title list was generated. (*This represents a subject search using the term "Robots—Fiction" in the regular catalog of Winnebago.*)

[Show transparency 5.25]

This is the subject screen from which the above choices were made in the regular catalog.

[Show transparency 5.26]

This is a list generated through a keyword search in Winnebago when using the terms **robot OR robots**. Point out to students that some titles are included that were not on the other two title lists. [Reshow transparencies 5.24 and 5.25 until this is clear.] Explain that the "keyword search" option can be a way to get at more resources.

Description of the Activity

[Show transparency 5.27]

Explain that in keyword search the computer searches three fields from each record in the database—title field, subject field, and note field. After the user indicates which of these fields or combination of fields (on the screen Winnebago uses the term "sources" rather than fields), the system looks for the occurrence of the requested word or phrase and, when there is a match, it selects and displays those records.

Explain that this can sometimes cause inappropriate materials to be retrieved because the computer cannot make judgments, but simply matches characters and displays what it finds. One example is to use the term "**riddle**" in a keyword search. What is expected are books containing jokes and riddles, but in addition other records appear as well.

[Show transparency 5.28]

Point out that **riddle** appears in the title field, and that this is why the record was selected by the computer even though it is not a book of riddles.

Call attention to the keyword search as a way to locate a half-remembered title. One example is using the term **Chinese** to retrieve the work of fiction in which one of the characters is a Chinese adolescent.

[Show transparency 5.29]

Point out the term **Chinese** in the note field. Remind students that they would not have found the title had they used the term **China**; since that would not have been an exact match with the search word. A search using "Chinese or China" *would* have produced this same book but also a longer list of titles.

For a basic, concise overview of Boolean search, refer to the one-page article by Ala and Cerabona (1992). If students are cognitively ready to consider further implications, the article by Bates (1987) clarifies certain considerations, such as keyword searching with terms or concepts. If the library collection is small, such a discussion may be premature for intermediate-age students.

Closure

Remind students that subject searching in the regular catalog may be preferable at times, but that keyword searching is a powerful option with which they will become more familiar as they gain experience with electronic databases. The key to successful use of any of these systems is to interact with them in a reflective and patient manner.

```
            The Cybil war

F
Bya     Byars, Betsy Cromer.
            The Cybil war / Betsy Byars ; illustrated by Gail
        Owens. -- New York : Viking, 1981.
            126 p. : ill.

            Summary: Simon learns some hard lessons about good and
        bad friendships when his good friend Tony's stories
        involve him in some very troublesome and complicated
        situations.
            1. Friendship--Fiction I. Owens, Gail, ill.
        II. Title
```

Winnebago CAT — Computerized Catalog

F1 Help

F4 Browse Authors

F5 Clear Screen

F6 Search by Subject

F7 Key Word Catalog

F8 Select Language

Enter Title: _____

Enter Search

Reprinted with permission from Winnebago Software Company.

TRANSPARENCY 5.2

```
F          Byars, Betsy.
BYA            The Cybil War / Illus. by Gail Owens. --
           Viking, 1981
           126p : illus.

               Simon learns some hard lessons about good and
           bad friendships.
               ISBN 0-67025-248-4

               1. Friendship--Fiction. I. Title

                                                               Fic
```

Reprinted with permission from Winnebago Software Company.

TRANSPARENCY 5.3

Ameritech Library Services

```
                                    DIALPAC
                         DIAL PAC (12 , ttyd1p1 )

Call Number      F BYA

    AUTHOR    Byars, Betsy Cromer.

     TITLE    The Cybil war /

 PUBLISHER    New York : Viking Press, 1981.

     DESC.    x, 126 p. : ill. ; 22 cm.

   TOPICS    1) Friendship -- Fiction.
```

Reprinted with permission of Ameritech Library Services.

TRANSPARENCY 5.4

```
        Winnebago CAT — Computerized Catalog

                                        ┌─────────────────────────┐
                                        │ [F1] Help               │
                                        │ [F4] Browse Authors     │
                                        │ [F5] Clear Screen       │
                                        │ [F6] Search by Subject  │
        Enter Author:_____   │ [F7] Key Word Catalog   │
                                        │ [F8] Select Language    │
                                        │                         │
                                        └─────────────────────────┘

 [Enter] Search
```

Reprinted with permission from Winnebago Software Company.

Complete Winnebago CAT — Computerized Catalog 48 Found
(Author = Byars, Betsy .)

Call #	Material Title	Author	Location	Mat.Type	Status
E BYA	Go and hush the baby	Byars, Be		Early	
E BYA	The lace snail	Byars, Be		Early	
E BYA	The Golly Sisters go West	Byars, Be		Early	
E BYA	The Golly Sisters go West	Byars, Be		Early	
F BYA	After the goat man	Byars, Be		Fiction	
F BYA	Beans on the roof	Byars, Be		Fiction	
F BYA	Beans on the roof	Byars, Be		Fiction	
F BYA	Bingo Brown and the languag	Byars, Be		Fiction	
F BYA	Bingo Brown and the languag	Byars, Be		Fiction	
F BYA	A Blossom promise	Byars, Be		Fiction	
F BYA	A Blossom promise	Byars, Be		Fiction	
F BYA	The Blossoms and the Green	Byars, Be		Fiction	
F BYA	The Blossoms meet the vultu	Byars, Be		Fiction	
F BYA	The computer nut	Byars, Be		Fiction	
F BYA	Cracker Jackson	Byars, Be		Fiction	
F BYA	Cracker Jackson	Byars, Be		Fiction	

| F1 | Help | F9 | Sort Results | F10 | Print Bibliography |
| Esc | Exit | Enter | Select | Del | Delete | ↑↓ | PgUp | PgDn | Home | End | Move |

Reprinted with permission from Winnebago Software Company.

TRANSPARENCY 5.6

Ameritech Library Services

```
                    DIALPAC
                    Dial Pac

          Welcome to the Online Catalog!

        Choose one of the following options:

            1.  Previous Menu
            2.  Alphabetical Title Search
            3.  Title Keyword Search
            4.  Name/Author Search
            5.  Alphabetical Subject Search
            6.  Subject Keyword Search
            7.  Call Number Search
            8.  Quit Searching

        Enter your selection(s) and press <Return>

    Commands: S = Shortcut on, BB = Bulletin Board, ? = Help
```

Reprinted with permission of Ameritech Library Services.

TRANSPARENCY 5.7

Ameritech Library Services

```
                                        DIALPAC
                              DIAL PAC (12 , ttyd1p1 )

Your search : BYARS, B
     AUTHOR (May be truncated)

   1.  Byard, Carole M.

   2.  Byars, Alvin W.

 >3.  Byars, Betsy Cromer.

   4.  Byars, Blaine D.

   5.  Byars, Guy,

   6.  Byas, Hugh.

   7.  Byatt, A. S. (Antonia Susan), 1936-
```

Reprinted with permission of Ameritech Library Services.

```
        Winnebago CAT — Computerized Catalog

                                              ┌─────────────────────────┐
                                              │ [F1] Help               │
                                              │ [F4] Browse Authors     │
                                              │ [F5] Clear Screen       │
                                              │ [F6] Search by Title    │
        Enter Subject:_____│ [F7] Key Word Catalog   │
                                              │ [F8] Select Language    │
                                              │                         │
                                              │                         │
                                              └─────────────────────────┘

  [Enter]  Search
```

Reprinted with permission from Winnebago Software Company.

TRANSPARENCY 5.9

```
591.92    Cole, Joanna.
COL           The magic school bus on the ocean floor / Illus. by
          Bruce Degen. -- Scholastic, 1992.

              On a special field trip on the magic school bus, Ms.
          Frizzle's class learns about the ocean and the different
          creatures that live there.

              1. Marine animals. 2. Ocean. I. Title

                                                          591.92
```

```
551.46    Marshak, Suzanna.
MAR           I am the ocean / Illus. by James Endicott. -- Arcade,
          1991.
              unp : illus.

              A lyrical paean to the ocean, in which the ocean sings the
          song of itself and all it contains.

              1. Ocean. I. Title.

                                                          551.46
```

Reprinted with permission from Winnebago Software Company.

TRANSPARENCY 5.10

```
551.46   Bramwell, Martyn.
BRA          The oceans. -- Watts, 1987.
             32p : illus. (Earth science library)

         Examines the physical features and marine life of the world's
    oceans, their currents and tides, & the methods by which we
    harvest the seas.

         1. Ocean. 2 Marine biology. I. Title.

                                                                551.46
```

```
574.92   Wu, Norbert.
WUN          Life in the oceans. -- Little, 1991.
             96p : illus. (Planet earth)

         An introduction to the many living things, from microscopic
    plants to huge sharks, that live in the ocean and discusses the
    importance of oceans to life on earth.

         1. Marine biology. 2. Ocean. I. Title.

                                                                574.92
```

Reprinted with permission from Winnebago Software Company.

TRANSPARENCY 5.11

```
551.46    Simon, Seymour.
SIM             Oceans. -- Morrow, 1990.
                32p : illus.

          Text and photos explore the physical characteristics, life
        forms, and fragility of the world's oceans.

          1. Ocean. I. Title.

                                                                        551.46
```

```
551.46    Bright, Michael.
BRI             The dying sea. -- Gloucester, 1988.
                32p : illus maps. (Survival)

          ISBN 0-53117-126-4

          1. Ocean. 2. Marine pollution. 3. Marine ecology.
        I. Title.

                                                                        574.5
```

Reprinted with permission from Winnebago Software Company.

TRANSPARENCY 5.12

```
363.73    Carr, Terry.
CAR           Spill! / The story of the Exxon Valdez. -- Watts, 1991.
              64p : illus maps.

              Includes bibliography.
              Discusses the carelessness and neglect that led to the oil
          spill in the Prince William Sound, Alaska; the cleanup effort; &
          the long-term consequences.
              1. Oil spills. 2. Tankers--Accidents. 3. Exxon Valdez
          (Ship). I. Title.

                                                                  363.73
```

Reprinted with permission from Winnebago Software Company.

Ameritech Library Services

```
                          DIALPAC
                  DIAL PAC (12 , ttyd1p1 )

Your search: Bethune, Mary McLeod,    1875-1955
      AUTHOR/TITLE/PUBLISHER                          PUB DATE
1.  McKissack, Pat, 1944—
        Mary McLeod Bethune /
        Chicago : Childrens Press,                   c1992.
2.  Wolfe, Rinna.
        Mary McLeod Bethune /
        New York : F. Watts,                         c1992.
3.  Halasa, Malu.
        Mary McLeod Bethune /
        New York : Chelsea House Publishers,         c1989.
4.  Meltzer, Milton,    1915-
        Mary McLeod Bethune /
        New York, N.Y. : Viking Kestrel,             1987.
5.  Sterne, Emma (Gelders) 1894-
        Mary McLeod Bethune.
        New York, Knopf,                             1957
                      - - - - 14 titles, More on next screen - - - -

Enter a title number for more detail :

   Commands: SO = Start Over, B = Back, <Return> = Next Screen, ? = Help

Menu: <Ctrl R-Shift>             19200 8N1              VT100 Online
```

Reprinted with permission of Ameritech Library Services.

TRANSPARENCY 5.14

Ameritech Library Services

```
                                    DIALPAC
                          DIAL PAC (12 , ttyd1p1 )

Call Number      Press C for Copy status
                 & Location Availability

   AUTHOR        McKissack, Pat,     1944-

    TITLE        Mary McLeod Bethune : a great American educator /

PUBLISHER        Chicago : Childrens Press,    c1985.

    DESC.        111 p. : ill., ports. ; 21 cm.

   NAMES         1) Bethune, Mary McLeod,   1875-1955.

  TOPICS         1) Afro-Americans -- Biography.
                 2) Educators -- United States -- Biography.
   NOTES         1) Includes index.
```

Reprinted with permission of Ameritech Library Services.

TRANSPARENCY 5.15

```
                      BLACKS—BIOGRAPHY

B
Bet      McKissack, Pat.
              Mary McLeod Bethune : a great American educator / by
         Particia C. McKissack, -- Chicago : Childrens Press,
         c1985.
              111 p. : ports.

              Summary: Recounts the life of the black educator, from
         her childhood in South Carolina to her success as teacher,
         crusader, and presidential advisor.
              1. Bethune, Mary McLeod, 1875-1955 2. Teachers
         3. Blacks--Biography I. Title
```

TRANSPARENCY 5.16

```
        BLACKS--BIOGRAPHY

B
Car    Mitchell, Barbara.
            A pocketful of goobers : a story about George
       Washington Carver / by Barbara Mitchell ; illustrations by
       Peter E. Hanson. -- Minneapolis : Carolrhoda, c1986.
            64 p. : ill. -- (A Carolrhoda creative minds book)

            Summary: Relates the scientific efforts of George
       Washington Carver.

            1. Carver, George Washington, 1864?-1943
       2. Agriculture--Biography 3. Blacks--Biography
       4. Peanuts I.
```

Ameritech Library Services

```
                                        DIALPAC
                              DIAL PAC (12 , ttydlp1 )

Call Number    Press C for Copy status
               & Location Availability

    AUTHOR    Mitchell, Barbara,    1941-

     TITLE    A pocketful of goobers :  a story about George
                   Washington Carver /

 PUBLISHER    Minneapolis : Carolrhoda Books,   c1986.

     DESC.    64 p. : ill. ; 23 cm.

     NAMES    1) Carver, George Washington,  1864?-1943.

    TOPICS    1) Agriculturists -- United States -- Biography.
              2) Peanuts.
```

Reprinted with permission of Ameritech Library Services.

TRANSPARENCY 5.17

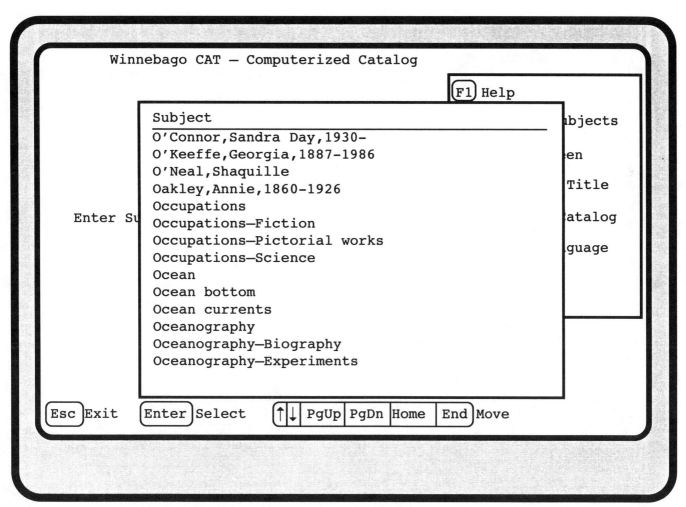

Reprinted with permission from Winnebago Software Company.

TRANSPARENCY 5.18

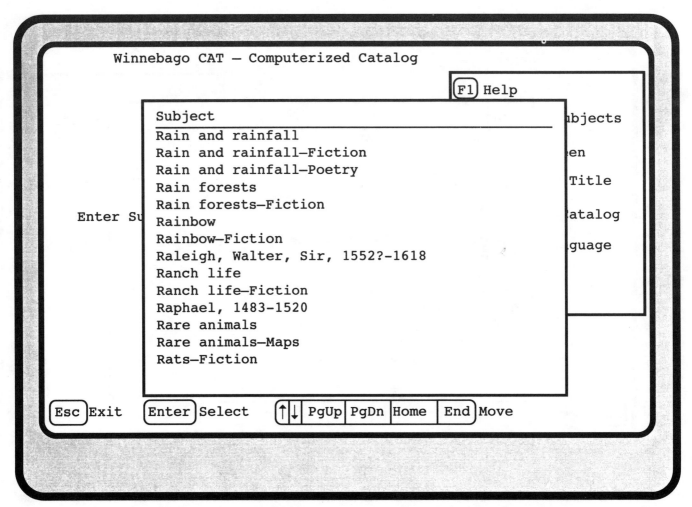

Winnebago CAT — Computerized Catalog

F1 Help

Subject bjects
Rain and rainfall en
Rain and rainfall—Fiction
Rain and rainfall—Poetry Title
Rain forests
Rain forests—Fiction atalog
Enter Su Rainbow
Rainbow—Fiction guage
Raleigh, Walter, Sir, 1552?-1618
Ranch life
Ranch life—Fiction
Raphael, 1483-1520
Rare animals
Rare animals—Maps
Rats—Fiction

Esc Exit Enter Select ↑↓ PgUp PgDn Home End Move

Reprinted with permission from Winnebago Software Company.

TRANSPARENCY 5.19

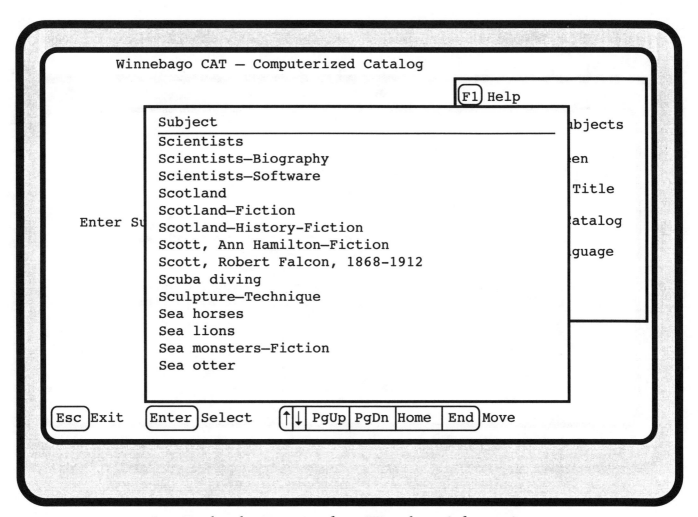

Winnebago CAT — Computerized Catalog

F1 Help

Subject
Scientists
Scientists—Biography
Scientists—Software
Scotland
Scotland—Fiction
Scotland—History-Fiction
Scott, Ann Hamilton—Fiction
Scott, Robert Falcon, 1868-1912
Scuba diving
Sculpture—Technique
Sea horses
Sea lions
Sea monsters—Fiction
Sea otter

Esc Exit Enter Select ↑↓ PgUp PgDn Home End Move

Reprinted with permission from Winnebago Software Company.

```
919.8    Swan, Robert.
SWA         Destination: Antarctica / Photos. by Roger Mear, Robert Swan,
         and Rebecca Ward. -- Scholastic, 1988.
            41p : illus maps.

            Follows the British adventurer Robert Swan and two other
         explorers on a 900-mile trek to the South Pole.

            2. Swan, Robert. 2. Mear, Roger. 3. Scott, Robert Falcon,
         1868-1912. 4. Explorers. 5. Antarctic regions. I. Title.

                                                                    919.8
```

Reprinted with permission from Winnebago Software Company.

TRANSPARENCY 5.21

```
920      Bolton, Sarah Knowles., 1841-1916.
BOL          Famous men of science / [by] Sarah K. Bolton, revised by
         Edward W. Sanderson, illustrated by Constance Joan Naar. -- New
         York : Thomas Y. Crowell company, [1946].
             v, [2], 308 p. : illus. (ports.) ; 21 cm.

             "Copyright, 1926 … Twentieth printing, October, 1946. (First
         printing of third edition)"
             Nicolaus Copernicus.--Galileo Galilei.--Sir Isaac Newton.--
         Carl Linnaeus.--Sir William Herschel.--Michael Faraday.--Louis
         Agassiz.--Charles Robert Darwin.--Louis Pasteur.--Lord Kelvin.--
         Thomas Alva Edison.--The Curies.--Guglielmo Marconi.--Luther
         Burbank.--Walter Reed.--The Comptons.--Sir Alexander Fleming.--
         Albert Einstein.--Harold C. Urey.
             1. Scientists--Biography. I. Sanderson, Edward W. II.
```

Reprinted with permission from Winnebago Software Company.

TRANSPARENCY 5.22

```
Call #                   Material Title              Author    Mat. Type  Status

629.8 GRE   Robots.                                  Greene, C  600 - 699    In
629.8 LAU   Get ready for robots!                    Lauber, P  600 - 699    In
629.8 LIT   Robots and intelligent machines.         Litterick  600 - 699    In
629.8 PET   Robots.                                  Petty, Ka  600 - 699    In
629.8 SIL   The robots are here                      Silverste  600 - 699    In

[Esc] Previous Screen [Enter] More Information  ↓↑ Move
```

Reprinted with permission from Winnebago Software Company.

Call #	Material Title	Author	Mat. Type	Status
F ASI	Norby, the mixed-up robot,	Asimov, J	Fiction	In
F BRI	Andy Buckram's tin men.	Brink, Ca	Fiction	In
F CON	Mishmash and the robot.	Cone, Mol	Fiction	In
F SLO	My robot buddy.	Slote, Al	Fiction	In

[Esc] Previous Screen [Enter] More Information ↓↑ Move

Reprinted with permission from Winnebago Software Company.

TRANSPARENCY 5.24

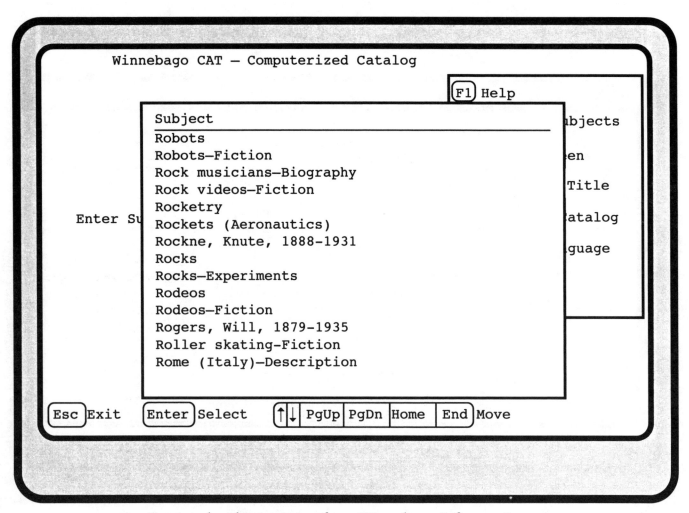

Reprinted with permission from Winnebago Software Company.

Transparency 5.25

```
                Winnegabo CAT -- Computerized Catalog
                Written For:

Call #                     Material Title              Author
001.64   HE    Computer basics.                    Hellman,
629.8    GRE   Robots.                             Greene, C
629.8    LAU   Get Ready for robots!               Lauber, P
629.8    LIT   Robots and intelligent mach         Litterick
629.8    PET   Robots.                             Petty, Ka
629.8    SIL   The robots are here                 Silverste
E MAR          Space case.                         Marshall,
E MAR          Jed's junior space patrol,          Marzollo,
E TIT          Anatole and the robot.              Titus, Ev
F ASI          Norby, the mixed-up robot,          Asimov, J
F BRI          Andy Buckram's tin men.             Brink, Ca
F CON          Mishmash and the robot.             Cone, Mol
F SLO          My robot buddy.                     Slote, Al
```

Reprinted with permission from Winnebago Software Company.

```
      Winnebago CAT — Computerized Catalog

                                                    ┌──────────────────────┐
                                    Matches         │ F1  Help             │
                                                    │                      │
 Word/Phrase: _____           │ F2  Change Boolean   │
         (From Subjects or Titles or Notes)         │                      │
                    AND                             │ F3  Include Author   │
 Word/Phrase: _____ (Optional)        │     or Other Index   │
                                                    │ F4  Browse Key Words │
         (From Subjects or Titles or Notes)         │                      │
                                                    │ F5  Clear Screen     │
                                                    │                      │
                                                    │ F6  Change Source    │
                                                    │                      │
                                                    │ F7  Regular Catalog  │
                                                    │                      │
                                                    │ F8  Select Language  │
                                                    │                      │
                                                    │ F9  Browse           │
           Using: [X] Material Database             │     Referenced Words │
                  [ ] Informational Database        │ F10 Select Database  │
                                                    └──────────────────────┘
 Enter  Search  ⇅ Move
```

Reprinted with permission from Winnebago Software Company.

TRANSPARENCY 5.27

```
F          Jensen, Dorothea.
JEN             The riddle of Penncroft Farm. -- Harcourt, 1989.
                180p : map. (Great episodes)

                Includes bibliography.
                When Lars Olafson moves to a farm near Valley Forge, he meets
           the ghost of an 18th-century boy, who recounts his adventures
           during the American Revolution.
                1. Ghosts--Fiction. 2. Pennsylvania--History--Fiction.
```

Reprinted with permission from Winnebago Software Company.

TRANSPARENCY 5.28

```
F          Ellis, Sarah.
ELL             Next-door neighbors. -- McElderry, 1990.
                154p.

                Her family's move to a new town in Canada leaves shy 12-year-
           old Peggy feeling lonely & uncomfortable, until she befriends
           George and the Chinese servant of her neighbor.

                1. Friendship--Fiction. 2. Bashfulness--Fiction. 3. Family
           life--Fiction. 4. Canada--Fiction. I. Title

                                                                   Fic
```

Reprinted with permission from Winnebago Software Company.

TRANSPARENCY 5.29

Chapter 6

Modifying the Subject Authority: Cataloging for Kids

Those professional library media specialists who are committed to developing library collections of depth and relevance, and who hold central their instructional role, have always sought ways to expand intellectual access to materials. Within such constraints as little or no clerical help and limited budgets, they have worked behind the scenes on unwieldy and often poorly maintained card catalogs. Some graduates of rigorous AACR2 cataloging courses have held high the banner of standardization. Some equally well intentioned librarians have abbreviated their catalogs' entries and employed arbitrary headings that might confuse even motivated searchers. Providing meaningful cataloging of resources remains an essential but difficult task for the library media specialist.

The reader is directed to Murphy's article from her book (1992), "Access to Information: The Effect of Automation." It contains a summary of the history of cataloging of children's materials, including the Library of Congress's Annotated Card Program (ACP), which has been in effect since the early 1960s, and the guidelines for standardization (hereafter "Guidelines" 1983) later developed by the Cataloging of Children's Materials Committee (CCS) of the Resources and Technical Services Division (RTSD) of the American Library Association in conjunction with the Children's Literature Section of the Library of Congress. (These guidelines first appeared in *Top of the News* [fall 1983] and described the bibliographic elements considered standard for an AC record.) In this same article, Murphy also includes a concise discussion about designing an OPAC system that meets the needs of school users.

Bates (1986) provides an excellent summary of system design principles that improve subject access in online catalogs. Simply put, she advises forgetting economy when it comes to the number of subject headings—redundancy is more than acceptable. The idea is to increase the likelihood of a match between the subject headings and the words used by the searcher. She urges the use of additional cross-references and the inclusion of a thesaurus in the system.

Many other researchers and writers have commented on aspects of indexing practice and on system options that open up new levels of access to information and to ideas for users of all ages. Educational professionals would do well to stay current with the rapid development both in theoretical views of and practical applications for automated libraries. One example of this rapid change is especially notable. Most of the microcomputer stand-alone OPACs available on the market in 1985 did not conform to the MARC standard; by 1991 there was almost universal conformity to this standard (Murphy 1992, p. 170).

Of particular relevance to this discussion of cataloging modification is Murphy's 1985 school library OPAC user survey. She reported that the majority of respondents did not make added entries or subject or note enhancements to individual records even though they agreed that cataloging enhancements were critical. Most reported the continued use of *Sears List of Subject Headings*. When enhancements were

made, they generally related to instructional issues, such as curriculum units, reading levels, and content analysis (Murphy 1992, p. 170).

How does this affect the student? If the library catalog has both a student instructional function ("This is a way the system stores information, and this is how you get it to serve you.") and a locational function ("Where are the snake books?"), these issues of its design, indexing, and modification must be balanced carefully.

In an elementary school library media center, the users of the library catalog exhibit a wide span of cognitive abilities as described by Piaget, ranging from the concrete-operations stage to the formal-operations stage of development. Recognizing that all students will not have the requisite skills of logic as they begin to use the library catalog independently, the library media specialist should intervene informally in a timely and effective manner.

Formal instruction should focus on the system in place in the school library media center while continually reminding students of any differences they might encounter in the public library, where they will surely find themselves after school hours. I believe that students need a basic awareness of structure and rules at the adult level; therefore, standardization of either a card catalog or online catalog is important, and a simplified system should not be adopted.

Enhancements to increase student access to materials should be an ongoing project. Any modification to purchased catalog card sets relies on the same professional considerations as those for online catalogs using full MARC records acquired from commercial vendors. For those who maintain manual library catalog systems, the points that follow can be applied where appropriate.

With MARC records as the predominate basis of cataloging in OPACs, the *Library of Congress Subject Headings*, including modifications of the Annotated Card Program for children's materials, takes precedence over the *Sears List of Subject Headings*. Library media specialists have had the long-standing task of updating their catalogs as new editions of their favored *Sears* listing became available. Now, if instead, they follow the recommendation of the American Library Association regarding standardization of subject headings ("Guidelines" 1983), they have a tremendous task of conversion to LC headings. Some of this task may be accomplished by retrospective conversion of a card catalog into machine-readable form. Some manual changes to catalog records will be required.

One publication (Fountain 1993) makes available the subject authority file of the Eanes Independent School District in Westlake Hills, Texas. I view the work as a great service to the profession. Fountain's *Headings for Children's Materials* reconciles the *Sears List of Subject Headings* with the *Library of Congress Subject Headings,* as modified by the ACP, along with any changes published through 1992 in the *Cataloging Service Bulletin* of the Library of Congress. It provides an easy-to-use checklist of authorized terms and encourages increasing the number of subject headings assigned to an item because the computer is easily able to accommodate this practice.

In teaching students about points of access in the library catalog, it is important to remember that traditionally one to three subject headings of the most specific descriptive nature were used. With the Annotated Card Program, catalogers began to use both the specific and the broader terms. Books that were published prior to 1965, therefore, have fewer headings and may be overlooked by the young searcher.

The ACP modifications for geographic names and some subdivisions should be noted. These geographic designations are extremely confusing to young readers. Authorized terms, for example, include **Southern States**, **Southwestern States**, **Northern States**, and **Middle Atlantic States**. The word "states," however, does not appear in some geographic area designations. We find **Great Lakes**, **Great Plains**, **West (U.S.)**, **Northwest Pacific**, and **Northwest Coast of North America**. Since United States geography is a common curriculum topic for fourth graders, the inconsistency frustrates them as they look up materials for assignments. This would be a logical area to target for modification by the library media specialist. "Guidelines" 1983 provides for the creation of new subject headings based on other standard reference sources. Consistency with encyclopedia or textbook designations is desirable.

When the library media specialist creates new subject headings that are assigned to records, it is important to keep an up-to-date authority file. Many librarians may have recorded such notes inside a copy of *Sears* or kept an external card file or printed list. Online catalogs that automatically build the authority file as enhancements are made, or, as new records are entered, hold a tremendous advantage over manual entries. Consistency is critical because, just as small differences can make similar records fall far apart in an alphabetized card file, so, too, will the "unknowing" computer display all variations of the same heading. Some systems provide for global editing of records, which is desirable for updating term usage. Rather than changing terms, however, creating *See also* references may be an alternative, as the older terms provide the student with visible displays of linkages that could be important later in their use of other resources.

Many writers have urged the inclusion of cross-references in online library catalogs. Because these are not a part of the MARC record, they must be added deliberately. When librarians, as consumers of these products, make such demands on program developers, the market will respond with system changes that include or facilitate the addition of these references.

An example of where cross-references are especially important for young people is in the study of Native Americans. If the student approaches the catalog with this culturally preferred term, there should be a *See* reference leading to **Indians of North America**, which is the cataloging standard. This large category of diverse materials may have many inconsistencies in the catalog depending on the subdivisions used. Some catalogs have used the names of specific nations and tribes as subdivisions; some have used the accepted terms: **Woodland Indians**, **Pueblo Indians**, **Cherokee Indians**, etc. Some have used both, but are inconsistent in that use. Again, it may be important to create additional headings, such as **Plains Indians**, since this is often one of the designations made in class assignments, or to include, at the least, a cross-reference.

In some cases, the preferred term is difficult for young children to spell even if they happen to think of it, so a cross-reference from a common, spellable word such as **Aliens**, for example, will lead them to **Extraterrestrial Being**.

A practicing library media specialist or teacher will have many examples of subject headings that are confusing and inaccessible to students. As these occur in a real-life situation, they can become the target areas for enhancement. In the meantime, it is recommended that librarians make available at the workstations a printed copy of the subject authority and any thesauri that might stimulate associative thought, and continue with instruction that focuses on the need for flexibility in applying search word strategies.

In the "Guidelines" 1983, the only note required in a catalog record is a noncritical annotation not exceeding thirty words. An exception to the requirement of a summary note is in those cases where a contents note is given. Catalogers for LC's Annotated Card Program create these annotations—descriptions of the nature and scope of a work—but, in my view, do not always use language that is easily understood by children. The library media specialist may find it helpful to amend these annotations. If notes are modified, expanded, or added, deliberate effort should be made to include terms likely to be searched, if "keyword searching" is an option of the particular system. The practice of including curriculum information and reading level in the note can be very helpful as well. Even if a contents note is included in the record, an additional summary note benefits the searcher.

The relative ease of modifying data in an online system, coupled with the desire to make the system responsive to needs and search behavior, influences the media professional to work ever more diligently to get it right. It is important to keep a balance, recognizing that while there is always more to do, students will learn even from an imperfect system. They will work their way ultimately to resources that open up knowledge and pleasure for a lifetime.

Chapter 7

Designing Topical Search Assignments: Collaborative Planning

Beginning in the primary grades, students appear in the library media center with assignments to "look up such-and-such." They should always be welcomed and be assured that they have come to the right place with their questions.

Between impromptu student-initiated visits and formal research-paper assignments lies a range of information problem-solving experiences. The inclusion of topical search assignments as a final chapter does not suggest that such assignments will not, or should not, be made even as the lessons in this book are being taught.

We want students to meet with success in completing an information problem-solving task. Therefore, such assignments, whenever they occur, must be carefully structured, and prerequisite knowledge and skills must be identified by the teacher and library media specialist.

Stripling and Pitts offer sound guidance in planning a research unit in which the thought level of the intended research is a primary consideration. See their *Brainstorms & Blueprints: Teaching Library Research As a Thinking Process* with its six levels of research complexity (Libraries Ulimited 1989).

Turner, urging collaboration between teacher and library media specialist, clearly sets out four factors that determine which information skills are required for a particular assignment or unit of instruction: (1) levels of learning, (2) number of information sources to be used, (3) amount of guidance to be provided, and (4) characteristics of the learner (Turner 1991, pp. 14–15).

The library media specialist and the teacher, planning separately and cooperatively, will help ensure quality learning experiences and avoid developmentally inappropriate assignments. The following checklist provides a reminder of key points.

A CHECKLIST FOR THE TEACHER

☐ Are the questions or topics assigned at an appropriate level of difficulty for the students?

☐ Do the students understand the assignment?

☐ Have I checked to see that the school and/or public library resources can support the assignment? Have I determined
(a) the amount of information written on the topic?
(b) the number of copies of sources available?
(c) the reading level of sources?

☐ Have I discussed the assignment and my expectations with the library media specialist?

☐ Have I made it clear that students must write in their own style and must use their own vocabulary? Have I demonstrated how to paraphrase?

☐ Do I expect synthesis of information from multiple sources? Have these skills been taught?

☐ Have I placed an arbitrary or unrealistic expectation of length on the written portion of the assignment?

☐ Have I provided for intervention and reteaching at all stages of the search process so that success is likely?

☐ Have I provided for further practice in determining search word strategies for students having difficulty (e.g., asked the library media specialist to reteach selected class members, or used peer teaching where appropriate)?

A Checklist for the Library Media Specialist

☐ Am I familiar with the textbooks and curriculum guides used in my school?

☐ Have I suggested topics for investigation that the collection can support?

☐ Have I suggested sources that are useful for the topic under consideration? Are these sources up-to-date?

☐ Have I offered to set up a reserve shelf, an overnight checkout, or a class deposit to facilitate optimal use of the resources?

☐ Have I acquired materials from outside school sources if needed to support the assignment?

☐ Have I anticipated difficulties students might face with the library catalog and made modifications or improvements where possible?

☐ Have I discussed with the teacher his or her view of the relative importance of *locating* the information compared with *extracting* the information?

☐ Have I observed the students working on this assignment in the library media center, and have I provided feedback to the teacher?

☐ Have I offered to work with those students who might need to review search word strategies, paraphrasing, summarizing, etc.?

☐ Have I expressed willingness to support the assignment to its conclusion by evaluating with the teacher the level of difficulty of the task, by evaluating the adequacy of the media center collection, by checking any documentation questioned by the teacher, and by displaying completed student work?

RELATING LIBRARY MEDIA CENTER ACTIVITIES TO CURRICULUM TOPICS

School library literature abounds with suggestions for integrating library media center activities with classroom units. Several of the lessons in this book demonstrate how curriculum topics can serve as the content basis for the lessons. What unifies these cooperative efforts is the mutual desire to promote critical and creative thinking by students as they approach their studies.

As topics for investigation become more complex, thinking about the process and applying search word strategies will always be important first steps for students in their search for information.

Appendix A

Topics for Cross-References

(as found in *The World Book Encyclopedia*, 1994 edition)

Volume	Entry Word and Cross-Reference	
A	Alternating current	*See* Electric current, etc.
	Arctic wolf	*See also* Wolf.
B	Barnstorming	*See* Airplane (The golden age).
	Boston Tea Party	*See also* Adams, Samuel; Boston Port Act, etc.
C-Ch	Canadian Mounted Police	*See* Royal Canadian Mounted Police.
	Carver, George Washington	*See also* George Washington Carver National Monument; Tuskegee University; Sweet potato.
Ci-Cz	Cloud seeding	*See* Rainmaking.
	Comics	*See also* Capp, Al; Schulz, Charles M.; Cartoon.
D	Deep-sea diving	*See* Diving, Underwater.
	Doyle, Sir Arthur Conan	*See also* Holmes, Sherlock.
E	Earphones	*See* Headphones.
	Elbow	*See also* Funny Bone.
F	Fire engine	*See* Fire department (fire department equipment).
	Flintlock	*See also* Firearm; Musket, etc.
G	Giant sequoia	*See* Sequoia (with picture).
	Genghis Khan	*See also* Mongol Empire.
H	Hearing	*See* Ear (The sense of hearing).
	Hubble Space Telescope	*See also* Hubble, Edwin P.; Pluto; Telescope.

Volume	Entry Word and Cross-Reference	
I	Incisor	*See* Teeth (Permanent teeth).
	Illegal alien	*See also* Border Patrol, United States; Deportation.
J-K	Jeanne D'Arc	*See* Joan of Arc, Saint.
	Kaleidoscope	*See also* Reflection.
L	Lifesaving	*See* Swimming (Water safety); Drowning, etc.
	Lincoln Memorial	*See also* Washington, D.C. (picture).
M	Mount Vesuvius	*See* Vesuvius.
	Mammoth	*See also* Fossil (How fossils form); Mastodon; Prehistoric animal (picture).
N-O	NATO	*See* North Atlantic Treaty Organization.
	Nightmare	*See also* Dream.
P	Peach State	*See* Georgia.
	Polo, Marco	*See also* Exploration (picture); Kublai Khan.
Q-R	Rain Forest	*See* Tropical Rain Forest.
	Roman Numerals	*See also* Arabic numerals; Numeration systems (History).
S-Sn	Saint Valentine's Day	*See* Valentine's Day.
	Sioux Indians	*See also* Crazy Horse; Gall; Red Cloud; Sitting Bull, etc.
So-Sz	Soundproofing	*See* Acoustics; Insulation.
	Sputnik	*See also* Jordell Bank Observatory.
T	Toe	*See* Foot.
	Tonsil	*See also* Tonsillitis; Adenoids.
U-V	UFO	*See* Unidentified flying object.
	Vampire	*See also* Dracula; Stoker, Bram.
W-Z	War Between the States	*See* Civil War.
	ZIP Code	*See also* Post office (Sorting).

Appendix B

Suggested Online Services and Database Software

ONLINE COMMERCIAL SERVICES

Classroom PRODIGY
PRODIGY Services
445 Hamilton Avenue
H8B
White Plains, NY 10601

Scholastic Network
Scholastic, Inc.
555 Broadway
New York, NY 10012

(For a more complete listing, see "Appendix: Products and Service Directory," in Epler 1989, pp. 127-134.)

DATABASE SOFTWARE

Bank Street Filer
Broderbund Software
17 Paul Drive
San Rafael, CA 94903

FileMaker Pro
Claris Corp.
P.O. Box 58168
Santa Clara, CA 95052-8168

Friendly Filer
Houghton Mifflin Co.
222 Berkeley Street
Boston, MA 02116-3764

MECC Dataquest
MECC Educational Computing Company
3490 Lexington Avenue North
St. Paul, MN 55126-8097

Appendix C

Templates for Transparencies

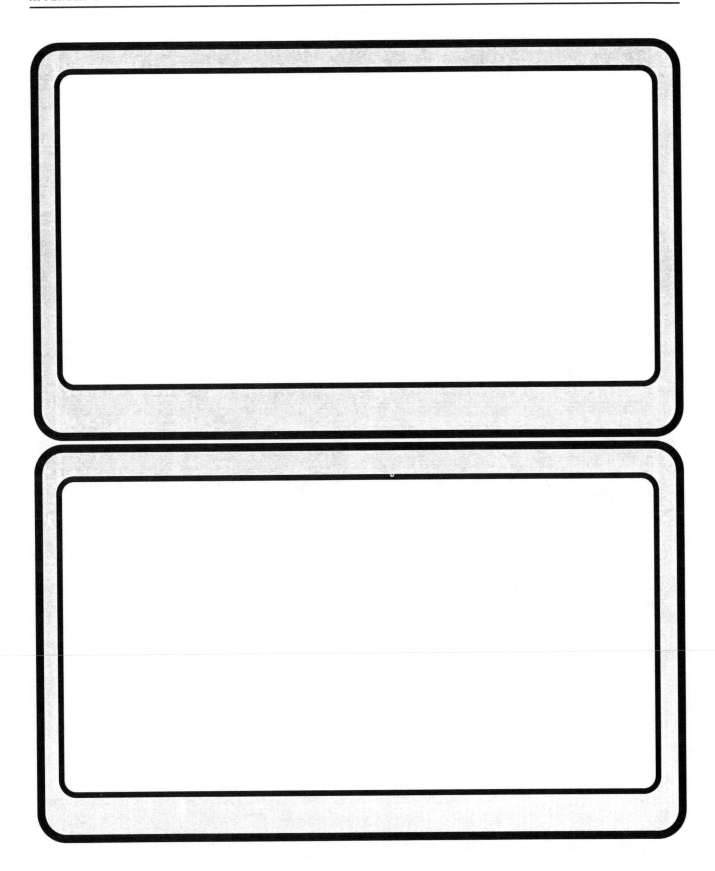

Bibliography

Ala, Judy, and Kathy Cerabona. "Boolean Searches, a Life Skill," *School Library Journal* 38 (November 1992): 42.

American Library Association Presidential Commission on Information Literacy. Final Report. Chicago: American Library Association, 1989.

Bates, Marcia J. "How to Use Information Search Tactics Online," *Online* 11 (May 1987): 47–54.

Bates, Marcia J. "Information Search Tactics," *Journal of the American Society for Information Science* 30 (July 1979); 205–214.

Bates, Marcia J. "Subject Access in Online Catalogs: A Design Model," *Journal of the American Society for Information Science* 37 (November 1986): 357–376.

Bertland, Linda H. "An Overview of Research in Metacognition: Implications for Information Skills Instruction," *School Library Media Quarterly* 14 (winter 1986): 96–99.

Callison, Dan. "School Library Media Programs and Free Inquiry Learning," *School Library Journal* 32 (February 1986): 20–24.

Cochran, Pauline A., ed. *Improving LCSH for Use in Online Catalogs: Exercises for Self-Help with a Selection of Background Readings.* Englewood, Colorado: Libraries Unlimited, 1986.

Dalrymple, Prudence. "Retrieval by Reformulation in Two Library Catalogs: Toward a Cognitive Model of Searching Behavior," *Journal of the American Society for Information Science* 41 (June 1990): 272–281.

Davey, Beth. "Thinking Aloud: Modeling the Cognitive Processes of Reading Comprehension," *Journal of Reading* 27 (1983): 44–47.

Eisenberg, Michael B., and Robert E. Berkowitz. *Information Problem-Solving: The Big Six Skills Approach to Library and Information Skills Instruction.* Norwood, New Jersey: Ablex Publishing Corporation, 1990.

Epler, Doris. *On-Line Searching Goes to School.* Phoenix, Arizona: Oryx Press, 1989.

Fidel, Raya. "Organizing, Indexing, and Retrieving Information," *School Library Media Quarterly* 17 (summer 1989): 206–209.

Fountain, Joanna F. *Headings for Children's Materials: An LCSH/Sears Companion.* Englewood, Colorado: Libraries Unlimited, 1993.

"Guidelines" 1983. *See* RTSD/CCS Cataloging of Children's Materials Committee. "Guidelines for Standardized Cataloging of Children's Materials," *Top of the News* 40 (fall 1983); 49–55.

Hooten, Patricia A. "Online Catalogs: Will They Improve Children's Access?" *Journal of Youth Services in Libraries* 2 (spring 1989): 267–272.

Hughes, Carolyn S. "Teaching Strategies for Developing Student Thinking," *School Library Media Quarterly* 15 (fall 1986): 33–36.

Kuhlthau, Carol C. "Implementing a Process Approach to Information Skills: A Study Identifying Indicators of Success in Library Media Programs," *School Library Media Quarterly* 22 (fall 1993): 11–18.

Kuhlthau, Carol C. "Inside the Search Process: Information Seeking from the User's Perspective," *Journal of the American Society for Information Science,* 42 (June 1991): 361–371.

Kuhlthau, Carol C. *Seeking Meaning: A Process Approach to Library and Information Services.* Norwood, New Jersey: Ablex Publishing Corporation, 1993.

Kulleseid, Eleanor R. "Extending the Research Base: Schema Theory, Cognitive Styles, and Types of Intelligence," *School Library Media Quarterly* 15 (fall 1986): 41–48.

Liebscher, Peter, and Gary Marchionini. "Browse and Analytical Search Strategies in a Full-Text CD-ROM Encyclopedia," *School Library Media Quarterly* 16 (summer 1988): 223–233.

McDonald, Frances M. "Information Access for Youth: Issues and Concerns," *Library Trends* 37 (summer 1988): 28–42.

Mancall, Jacqueline C., Shirley L. Aaron, and Sue A. Walker. "Educating Students to Think: The Role of the School Library Media Program," *School Library Media Quarterly* 15 (fall 1986): 18–27.

Mancall, Jacqueline C. "Examining the Successful Retrieval of Information by Students Using Online Databases," *School Library Media Quarterly* 16 (summer 1988): 256–259.

Marchionini, Gary. "Information-Seeking Strategies of Novices Using a Full-Text Electronic Encyclopedia," *Journal of the American Society for Information Science* 40 (January 1989): 54–66.

Miller, Marilyn L., and Marilyn L. Schontz. "Expenditures for Resources in School Library Media Centers, FY '91–'92." *School Library Journal* 39 (October 1993): 26–36.

Molholt, Pat. "Research Issues in Information Access," *School Library Media Quarterly* 17 (spring 1989): 131–135.

Moll, Joy K. "Children's Access to Information in Print: An Analysis of the Vocabulary (Reading) Levels of Subject Headings and Their Applicability to Children's Books." Ph.D. diss., Rutgers University, 1975.

Moore, Penelope A., and Alison St. George. "Children as Information Seekers: The Cognitive Demands of Books and Library Systems," *School Library Media Quarterly* 19 (spring 1991): 161–169.

Murphy, Catherine, ed. *Automating School Library Catalogs: A Reader.* Englewood, Colorado: Libraries Unlimited, 1992.

Pappas, Marjorie L. "Information Skills for Electronic Resources," *School Library Media Activities Monthly* 11 (April 1995): 39–40.

Pappas, Marjorie L. "Presearch with Electronic Resources," *School Library Media Activities Monthly* 11 (June 1995): 35–37.

Pennsylvania. State Library. *Problem Definition Process: A Guide to Research Strategies.* ACCESS Pennsylvania, Pennsylvania Department of Education. January 1989.

RTSD/CCS Cataloging of Children's Materials Committee. "Guidelines for Standardized Cataloging of Children's Materials," *Top of the News* 40 (fall 1983): 49–55.

Sheingold, Karen. "Keeping Children's Knowledge Alive Through Inquiry," *School Library Media Quarterly* 15 (winter 1987): 80–85.

Stripling, Barbara, and Judy M. Pitts. *Brainstorms and Blueprints: Teaching Library Research as a Thinking Process.* Englewood, Colorado: Libraries Unlimited, 1989.

Teaching Students How to Learn: Ideas for Teaching Information Skills. Tasmanian Education Department, Hobart, Australia, 1986 (ERIC Document Reproduction Service No. ED 327 811).

Tenopir, Carol, Diane Nahl-Jakobovits, and Dara Lee Howard. "Strategies and Assessments Online: Novices' Experience," *Library and Information Science Research* 13 (1991): 237–266.

Turner, Philip M. "Information Skills and Instructional Consulting: A Synergy," *School Library Media Quarterly* 20 (fall 1991): 13–18.

Weiss, Jiri. "New Places to Go Online," *Technology & Learning* 14 (May/June 1994): 109–116.

Winecoff, Sandra R. "The Effects of Selected Instructional Interventions on the Information-Seeking Behavior of Fifth Grade Students." Ph.D. diss., University of South Carolina, 1987.

Zuiderveld, Sharon, ed. *Cataloging Correctly for Kids: An Introduction to the Tools,* rev. ed. Chicago: American Library Association, 1991.

Index

Abbreviations, 14, 39
Activities
 Database File, 106–107
 Fast-Fact Take-Out:
 Info–to–Go, 11–12
 Finding the Common
 Denominator, 26
 Finding Out About the
 Pilgrims, 35, 69
 Getting Started with Subject
 Searching, 17
 How Do These Words
 Relate, 39, 70
 Predicting Subject Headings
 for Science Books, 33, 68
Added entries, 155
African American, 14, 29, 121–
 122
Almanac, 80–81
Alphabetizing. *See* Word-by-
 word alphabetizing; Letter-
 by-letter alphabetizing
American Library Association,
 155, 156
Annotated Card Program, 155,
 156
Annotations, 120, 157
Assess, 9, 11, 24
Assignments, 7, 156, 159–162
Associative thought, 157

Authority file. *See* Subject
 authorities
Automation, 24, 113–154

Biography, 121–123
Boolean search options, 113,
 124
Brainstorm box, 36, 57, 78, 93
Broader word strategy
 (definition), 15

Cataloging enhancements, 155,
 156
Cataloging-in-Publication, 33,
 56
CD-ROM, 108–109
Children's Magazine Guide,
 86–88, 96–101, 103
Cognitive readiness, 5, 113,
 125, 155–156
Collaborative planning, 7, 158
Collective biography, 123
Contents note, 157
Cooperative learning, 6, 24,
 26, 27, 35, 40
Cross-references, 30, 76–79,
 87, 92, 157
Curriculum, 5, 24, 74, 113, 121,
 156, 162

Databases, 102–107, 110–112
Developmental stages. *See*
 Stages of development
Developmentally appropriate,
 5, 158
Dewey classification, 33, 36,
 37

Electronic encyclopedia, 108–
 109
Electronic storage, 102–154
Encyclopedia, 18, 76–79

Fields, 105–107, 115–116, 125

Geographic designations, 156
Global editing, 157
Graphic organizer, 25, 37, 61,
 62, 70
Guidelines (1983), 155, 156,
 157

Hands-on, 7, 24, 120
*Headings for Children's
 Materials*, 29, 53, 156

Idea search. *See* Electronic
 encyclopedia
Information literacy, 3, 9

Keyword option (online), 108, 113, 124–125, 157
Keyword search strategy (definition), 14

Lesson design, 6, 7, 9
Letter-by-letter alphabetizing, 74
Library of Congress Subject Headings, 29, 53, 155, 156

Magazines, 86–88
MARC, 115, 155, 156
Menus, 115, 117
Metacognitive skills, 5, 13
Midlevel entry point. *See* Point of entry
Modem, 113, 118

Narrower word strategy (definition), 15
Native American, 157
Natural language, 14
Nickname, 14
Note enhancements, 155

Online public access (OPAC), 113, 117, 155
Opening screens, 116, 119
Overlapping subject strategy (definition), 15

Parallel teaching, 9. *See also* Collaborative planning

Pen name, 14
Periodicals. *See* Magazines
Phrases, 14, 15, 30
Piaget, 156
Pilgrims, 35–40
Poetry indexes, 89–90
Point of entry, 29, 80, 82, 156
Public access. *See* Online public access

Readers' Guide to Periodical Literature, 86
Related word strategy (definition), 14
Retrieval, 104

Search word strategies (definition), 5, 13, 21, 25
Sears List of Subject Headings, 29, 53, 155, 156
See reference. *See* Cross-references
See also reference. *See* Cross-references
Science projects, 32–33
Simplified system (catalog), 156
Source approach, 74
Stages of development, 74
Subdivisions, 29
Subject authorities, 29, 30, 32, 119, 155–157

Subject headings, 28–31, 33, 38, 67, 68, 120, 121, 155–157. *See also* Topics; Tracings
System design, 113, 117, 118, 120, 155, 157

Taxonomy of Thoughtful Research, 158
Teaching strategies, 6
Telephone directory. *See* Yellow pages
Term tactics, 5
Thinking aloud, 6, 13, 77, 104, 119
Tips (transparencies), 53, 56, 62
Title, honorific, 14, 122
Topics, 121. *See also* Subject headings
Tracings, 30, 32, 53, 119, 120
Truncation, 117

Union catalog, 118

Variant spellings, 38
Venn diagram, 39, 66, 71. *See also* Graphic organizer
Visual representation. *See* Graphic organizer

Word-by-word alphabetizing, 74

Yellow pages, 82–85